D1244047

LOST
GARY
INDIANA

JERRY DAVICH

FOREWORD BY CHRISTOPHER MEYERS

FORMER DIRECTOR OF PLANNING & DEVELOPMENT, CITY OF GARY

THE
History
PRESS

Published by The History Press
Charleston, SC 29403
www.historypress.net

Cover images courtesy of Cindy Bean.

First published 2015

ISBN 978-1-5402-1089-0

Library of Congress Control Number: 2015933533

Notice: The information in this book is true and complete to the best of our knowledge. It is offered without guarantee on the part of the author or The History Press. The author and The History Press disclaim all liability in connection with the use of this book.

To Karen, who not only reignited my passion for the rusted history of the Steel City but also routinely lit a fire under me to complete this book. I never would have taken this frightening plunge into the past if not for her love for Gary, for history and for me. Somehow, she made the city come back to life with every visit.

And to my family, whose ghosts still haunt Gary and whose memories served as a time machine each time I returned to my hometown.

CONTENTS

CONTENTS

FOREWORD

G ary, Indiana, rose from where sand dunes and sloughs once reigned supreme—a city formulated for steel fabrication along the southern shores of Lake Michigan.

Gary was a city modeled and shaped after the experiments of company towns like Pullman or Vandergrift. The founding of Gary began with the United States Steel Corporation's clandestine assembly of lands along the shoreline. With these lands under its control, the corporation was able to solidify plans to build a new and modern steelmaking plant. The corporation founded the Indiana Steel and Gary Land Companies to develop the mill complex and initial town site.

In a short time, Gary matured. The municipality's boundaries, population and spheres of influence quickly expanded. Gary became our region's center of commerce, our industrial core and our most influential city. Due to these factors, Gary became known by various monikers, such as the "Steel City," "America's Magic Industrial City" or "City of the Century."

Over the last one hundred years, Gary has experienced unparalleled challenges not seen with many cities. Gary has transitioned from a pioneer town to a regional power to a city whose purpose and identity is in flux. The city constitutes the struggles and challenges that defined twentieth-century America. Gary is an undertaking in creating an American ideal, architecture and planning, industry, politics, social justice and, in a more recent timeframe, decline.

The reality of decline and a disposable city is growing more apparent each day. Gary is becoming a city lost through population exodus, a city

adversely affected by the razing of buildings and a city endangered through indifference of its built heritage. Without such essential components needed to make up a city, the future of the once great city is indeed in peril.

Besides Gary, where are commissions of well-known architects and planners endangered of being lost going, or have they already been simply demolished and sent to landfill? Looking back, Gary has lost countless unique architectural designs. Included in these losses are lost residential commissions designed by Prairie School architects, such as Frank Lloyd Wright (Wynant House) and George and Arthur Dean (Land Company Housing and the Gleason Residence). Numerous public and commercial buildings have experienced a similar fate: East Side Branch Library, the Carnegie Library, the Joseph L. Silsbee–designed YMCA, the Bikos Building that contained V.J. Records, the Masonic Temple and block upon block of former commercial buildings within the downtown.

Even though many of the city's buildings have been lost to the ages, a good chunk of Gary's building stock remains. Throughout the city, examples of unique architectural styles, building materials and construction means can be found. Gary possesses buildings worthy of adaptive reuse that are composed of steel and concrete frames, old-growth lumber and skins of natural stone, cast concrete and terra cotta. With this in mind, an ever-increasing need for preservation and adaptive reuse exists for buildings that are currently endangered. Commissions that are on the cusp of being lost or facing the wrecking ball include the Palace Theatre; St. John's Hospital; H. Gordon and Sons; the Gary Heat, Light and Water Company Warehouse; Union Station; the Gary-Aldering Settlement House; Mahencia Apartments; and the United States Post Office.

Will Gary ever be able to overcome the escalating mindset of disposable city and architecture? As seen with many progressive cities, such as Boston, Seattle and even neighboring Chicago, Gary ought to focus on using its own history and built environment as underlying impetus and inspiration for revitalization. There is great hope that the information and retrospect contained within *Lost Gary* can help spark a discussion on fulfilling preservation and implementing revitalization, with an eye on ultimately strengthening the city and bringing back what helped make it magical.

CHRISTOPHER MEYERS
December 2014

PREFACE

My name is Gary. I was born in a prestigious boardroom at the turn of the twentieth century.

I came from the finest lineage, created from the deep-pocketed ideas of wealthy businessmen. My early nicknames were Miracle City, Magic City and the Steel City. People believed in me. I was the highest of hopes, the grandest of dreams.

The steel industry chose me to build its wealth on. It worked almost to perfection along my lakeshore, producing countless rolls of steel worth billions of dollars. I was richer beyond anyone's expectations. World-renowned draftsmen visited me to build majestic structures across my sprawling land. Educators made pilgrimages from across the country to model schools from my lesson plans. Citizens were proud to say my name. Outsiders felt privileged to stroll my streets.

I was a beautiful city, a lucrative city. Everyone wanted a piece of me.

With fame and riches, however, came power grabs and corruption. The steel industry hit tough times. I was hit harder than almost any other city in the nation. Racial unrest bubbled under the surface.

Steel built me up. Steel tore me down. My reputation began to tarnish. I began to rust. People took from me. They stole from me. I was sold out, abandoned by many, forgotten by others. Before I knew it, they turned their backs on me. I was no longer the future. I was the past.

PREFACE

My once majestic buildings started to crumble. My neighborhoods began to perish. My bustling streets are now lonely and barren. Businesses are boarded up. Factories reduced to ashes. A boomtown dwindled into a ghost town.

Economics bankrupted my promise. Politics kidnapped my potential. Crime stole my hope. Tens of thousands of gutted homes now gasp for one last breath.

Since my birth, I have lost so much—landmarks, people, pride.

My name is Gary. This is my story.

ACKNOWLEDGEMENTS

As the old adage goes, this book would not have been possible without the kindness, expertise and assistance of so many contributors in one form or another. All of them live in Gary, work in Gary or simply love Gary, even if the bloom of their flowery memories withered away decades ago.

Though in no particular order, I'm particularly grateful and appreciative to each of these patient souls who responded to my every ignorant question or repeated request, no matter how simple, irrelevant or seemingly stupid they must have appeared.

For starters, there are Steve McShane at the Calumet Regional Archives, who could have written this book in his sleep, and Jim Lane, who has written more about Gary than any transplanted Gary resident I know. And of course, there is Ron Cohen, who never hesitated to help me better understand the city, its storied past and its many complexities. My gratitude also goes to Tiffany Tolbert from Indiana Landmarks, as well as to David and Susan Gilyan, Samuel Love and Gary mayor Karen Freeman-Wilson, who shared her youthful memories and public office dreams.

Special thanks go to Cindy and Larry Bean for their passionate photography talents, as well as their unbridled enthusiasm for this book project and to Christopher Meyers, who not only wrote the foreword for this book but also answered every question I asked, shared every photo I needed and politely allowed me to pick his brain ad nauseam.

Finally, a profound thank-you goes to my family, who shared their insights, stories and memories of their hometown, too. And to every

ACKNOWLEDGEMENTS

person who felt compelled to share their intimate story about their beloved birthplace, thank you. Yes, many aspects of Gary will be lost forever but, as I learned time and again, its memories will not. These memories have endured and continue to endear residents to a city that lost its luster decades ago. This is the lasting legacy of Gary.

INTRODUCTION

C rime. Corruption. Poverty. Urban decay. Neglect. Abandonment. Fear. Disappointment. Blame. Regrets. Hopelessness.

To most Americans, this is what now defines Gary, Indiana, which remains the largest company town in this country. Though built sturdily on swale, dunes and swampland on the southernmost shore of Lake Michigan, Gary's fate was planted in quicksand. The city was founded in 1906 by U.S. Steel and named for the corporation's founding chairman, Elbert Gary. It was soon deemed the poster child for an urban experiment and duly given several nicknames by planners, architects and hucksters alike. All but one of those nicknames have long since faded away.

The Steel City was forged with hype and hope, dreams and sweat, political agendas and the almighty dollar. It attracted all kinds, from trailblazers and immigrants to entrepreneurs and adventurers. They came to the hardscrabble city in droves, writing its collective history while toiling in steel mills and factories along the lake's smokestack skyline. Mostly, though, it attracted hardworking folks searching for a simple share of the American dream.

"Gary, whatever else, is a paradox," wrote Arthur Shumway, a former *Post-Tribune* newspaper reporter in a sharply tongued 1929 essay. "It is busy. It is dull. It is modern. It is backward. It is clean. It is filthy. It is rich. It is poor. It has beautiful homes; it has sordid hovels." The city has always been littered with gangsters, drunkards, gamblers, prostitutes, greedy politicians and foul-mouthed ruffians. Crime has been a chronic problem in Gary since day one, not only in its later decades. To think otherwise is to commit a

crime of memory. Regardless of era or generation, there have been taverns, brothels and lean-tos for its hodgepodge of workers. "It has a past, but it has no traditions. Gary lies in the gutter and looks at the stars," Shumway wrote, echoing the timeless prose of Oscar Wilde.

The city remains in America's gutter, though it once had more stars than a galaxy of promises, including Michael Jackson, Alex Karras, Karl Malden, Frank Borman, Avery Brooks and Tony Zale. It boasted a school system embodying a revolutionary "work, study, play" model of learning. It seduced world-renowned architects, such as J.T. Hutton, George Maher and Frank Lloyd Wright. It pumped out more steel 'round the clock than its founders could ever imagine. Former Indiana governor Frank Hanly proclaimed: "I see a city rise as if by magic, in proportions vast and splendid." Gary did exactly this, until the magic was lost. When the steel mills shriveled, eventually quartering their labor force, the city's hopes were laid off, too, followed by lost residents, lost buildings, lost neighborhoods and, to a large degree, lost hope for any rebirth.

More than a century after its birth, Gary's once steely reputation has been lost to time, neglect and politics, forever tarnished as the rusted face of urban decay. Only one other American city, Detroit, has hit such rock bottom, according to a study by the Federal Reserve Bank of Chicago. Many other cities, of course, face similar straits. Gary is not alone, but it also is not as fortunate as those other troubled cities. Even the city's current mayor, who is Gary raised, Harvard educated and hopeful to a fault, admits the "City of the Century"—that is, last century—is in dire straits. It has been teetering on bankruptcy with a woeful budget, chronic poverty, devastating property tax problems and infamous crime statistics. The city's coffers once paid more than two thousand employees. In 2015, they employ fewer than nine hundred city workers. The city's 16 percent unemployment rate looms much higher by taking into account residents who stopped actively looking for jobs long ago. Four of every ten citizens live in poverty.

The city's urban experiment imploded in its own lakefront laboratory under a perfect storm of disastrous circumstances. It caused power struggles, racial problems, white flight and the loss of more than half of the city's population since 1960. In the city's heyday, Gary boasted almost 180,000 residents, a melting pot of people who eventually melted away to nearby towns. Gary's latest black eye took place in 2014, when an alleged serial killer buried his victims' bodies in abandoned homes in the fifty-four-square-mile city. The horrendous crime serves as a hint of the city's larger woes. Gary has become a victim of serial abandonment from region politicians,

state officials and its own people. Some of them buried their heads in the dunes when one of the nation's first black mayors took office. "Let us dare to make a new beginning," said Mayor Richard G. Hatcher on January 1, 1968, in his inaugural address. "Let us shatter the walls of the ghetto for all time. Let us build a new city and a new man to inhabit it."

Hatcher polarized an already polarized city. Supporters hailed him. Critics hated him. Many still do, blaming him for their lost city, even decades later. Anger remains a lingering remnant with former residents who are convinced their hometown was stolen from them, one block at a time. They didn't flee, they insist; they were kicked out. Racial turbulence only doused the volatile issue with gasoline.

However, other complex factors played a role in the city's decline: emerging global economics; the construction of interstate highways through Gary; the building of suburban malls; the demise of public transportation and accelerated dependence on cars; the failure of federal programs since the 1970s; the decline of unions; and a high incarceration rate of black males due to stiff drug laws, leading to single-parent households and spiraling economic woes. Gary wasn't the only Rust Belt city to fall victim to these circumstances. Dozens of other U.S. cities were also knocked out by these blindside punches and shots below the belt. Some of them have staggered to their feet. Others, like Gary, are still struggling to get off the mat.

City officials have been rebuilding ever since, looking for a new miracle in a city that has more demons than churches. A city that once buoyed an entire region of other communities is now a wreckage of regrets, disappointments and recollections. So much has been lost: schools, parks, businesses, theaters, restaurants, churches, civic buildings, people, history, homes and more.

This book will revisit and resurrect several lost landmarks of the long-rusted Steel City. From the dilapidated City Methodist Church, which serves as a telling microcosm for the city, to the neglected Union Station, which now transports only memories, as well as the once bustling business district that is now a ghost town of storefront façades. Plus, theaters that have gone dark decades ago. And churches whose congregations have fled the city to worship God from elsewhere.

Imagine, if you will, the memorable scene in the blockbuster film *Titanic* when the sunken vessel came back to life from its watery grave, if only for a movie. Similarly, *Lost Gary* will resurface forgotten landmarks, breathe life back into them and recall their importance, if only for a moment. If only within these pages. If only…

THE STEEL CITY'S EARLY FOUNDATIONS AND LOOMING FAILURES

U.S. STEEL COMES TO TOWN

My home is New York, but my heart is in Gary, Indiana.
—Elbert Gary, U.S. Steel board chairman

As far back as 1821, just five years after the founding of Indiana's statehood, a Hoosier land speculator, Indian agent and office holder named John Tipton condemned the sandy, swampy, forsaken northwest corner of Indiana. Tipton wrongly surmised that this region could never be settled and that "it would never be of any value to the state."

He was correct for several decades until, long after his death, the U.S. Steel Corporation decided to build its new mill on the southern shore of Lake Michigan. Finding it to be an ideal location adjacent to a major waterway and existing railways, the steel giant's board chairman liked its proximity to Chicago. His name—Elbert H. Gary.

A decade or so earlier, John D. Rockefeller chose nearby Whiting to build his world-renowned refinery, calling it Standard Oil Company, which is now BP Amoco. Why couldn't U.S. Steel create a similar world-renowned plant for steelmaking just down the shoreline, its board chairman wondered. Not only was Gary the largest company town ever constructed in America, its location was literally a city of hopes and a field of dreams, built on swampy marshland. Gary, who acted as the town's supreme leader, if not its heart

and soul, never lived there yet once boasted: "My home is in New York, but my heart is in Gary, Indiana." The self-described religious moralist promised to build a city "on a foundation that will stand…good schools, churches, law and order."

Through his guidance, U.S. Steel bought nearly ten thousand acres of land, which included several miles of needed shoreline for its steel production. At an average cost of $800 per acre, totaling $7.9 million—paid in cash through several clandestine transactions—the dreamy beginnings of the Miracle City and the Steel City took root. In conjunction with the Gary Land Company and Indiana Steel Corporation, both U.S. Steel subsidiaries, the companies began creating the town in 1906, named for Gary. The Indiana Steel Corporation developed the mill property, and the Gary Land Company supervised early construction of the town.

The new town-turned-city was built for the purpose of making money—lots of money—in a rising industrial world. And it proved true, realizing the riches that so many steel mill investors once imagined. This needs to be noted because much of what became lost in this now troubled city traces back to its earliest days—its earliest intentions, its earliest racial problems, its earliest greed, corruption and politics. This money-making foundation, in many ways, defines Gary's past, from the first stake nailed into the ground to the latest nail hammered into its coffin.

A century ago, the rest of the state considered Gary, if not the entire Northwest Indiana region, a "Hoosier stepchild." It accepted the region because it had to, not because it wanted to. The twenty-first century is no different, though Gary's steel mills continue to make money, greasy hand over greased fist. Along the way, the early origins of the city's ostracized identity in the state—thanks in part to Tipton—have come full circle.

Gary Land Company

Gary was conceived in the counting rooms and born in a jungle. As steel goes, so goes the world, and Gary is its prophet.
—Tom Knotts, Gary's first mayor and postmaster

As Gary's rags-to-riches-to-rags story illustrates, trying to escape its history is like trying to escape its identity. In May 1906, the Gary Land Company office building was built, making it the first permanent structure in the city. It served as

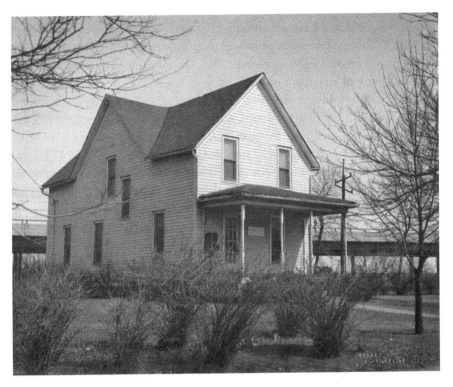

The Gary Land Company Building, constructed in 1906 as the first permanent structure in the city, housed the offices of the Gary Land Company, a subsidiary of U.S. Steel Corporation. *Calumet Regional Archives.*

the first town hall, polling place, post office and high school. It still stands, though it has been moved twice since its first location at Broadway and Third Avenue.

In 1981, the small home-style office was placed on the National Register of Historic Places and, the following year, restored to its original appearance. In July 2006, it was rededicated by city officials for the centennial celebration. A plaque on the building states: "The Centennial Celebration will allow an opportunity to build new bridges and mend old fences: geographically, economically, racially and generationally."

The building, now under the guardianship of the Gary Historical Society, is still in decent shape but not open to the public. It's one of the few structures in the city that has not been lost to time, neglect or urban decay. The same can't be said for the so-called First Subdivision, designed for skilled millworkers, managers and other factory workers in the Calumet Region at the time. A Gary Land Company poster from June 1907 states: "COME TO GARY: Become a factor in the building of this model city. Own your own home in Gary. The

First Subdivision will have a handsome, modern school building completed this year." The advertisement promised modern sewage systems, waterworks, gas plant and electric lighting system. And, the ad promised, all was offered "with no desire of making a profit."

The eight-hundred-acre development was strategically located just south of the steel mill, within walking distance of its front gates. Constructing the plotted development, however, was no easy task, as workers had to contend with harsh land, rough conditions and treacherous insects and animals. The First Subdivision was bounded by North Broadway on the north, Ninth Avenue to the south, Grant Street on the west and Virginia Street to the east. It should be noted that the city's streets west of the north–south Broadway were named in honor of U.S. presidents in order of their succession. Streets east of Broadway were named after states in order of their acceptance into the Union.

That same year, the town's population jumped to more than sixteen thousand from just a few hundred four years earlier. The rush was on, not only to live there but more importantly to nab a job in the fancy new mill by the lake. U.S. Steel also rushed to complete its property, with a single-minded goal of making money, not making any kind of a magic city.

It's estimated that more than $65 million was initially poured into the Gary Works project, with little attention paid to the model city being built around

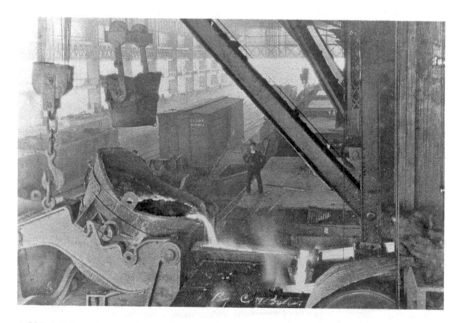

A U.S. Steel worker watches molten metal process through the mill in 1914. *Calumet Regional Archives.*

it. "Urban planning" was an unnecessary oxymoron to company officials, who didn't care that its smokestack skyline would be located so closely to so many homes. An urban planner named Graham Taylor later quipped, "The Gary town plan is likely to create in a decade conditions which can only be remedied by a Caesarean operation." His criticism did nothing to stop the birth of the vaunted mill, which pumped out its first steel products in 1909.

The company also constructed several subsidiary plants to enhance its integrated production process. Many other steel-related factories and firms opened to cater to the steel market boom of

A U.S. Steel open-hearth furnace in action. *U.S. Steel Gary Works Photograph Collection.*

the early twentieth century. However, unlike U.S. Steel, which still pumps out millions of tons of steel each year, many of those plants have closed. Each one has been another damaging loss for the city. For example, the National Tube Division, which opened in 1926 and, at its peak, employed more than 2,200 workers, was forced to close in 1985, about the same time as the Gary Screw and Bolt Company, located on the city's east side, near Aetna.

"The 1980s were devastating with the downsizing of the steel industry and the loss of tens of thousands of jobs at Gary Works and other local steel makers," said Steve McShane, curator of the Calumet Regional Archives at Indiana University Northwest. On a related note of loss, innovative technology has helped cut U.S. Steel's plant workforce from roughly twenty thousand in its gravy days to fewer than five thousand in 2014. "On top of that, many industrial plants closed or moved, causing even more job loss in the area," McShane said.

Other notable losses include the Anderson Company, which left the city during that decade; the Budd Company; Standard Steel Spring; and Union

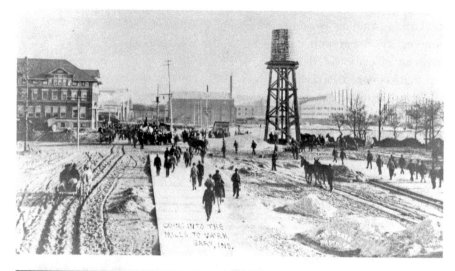

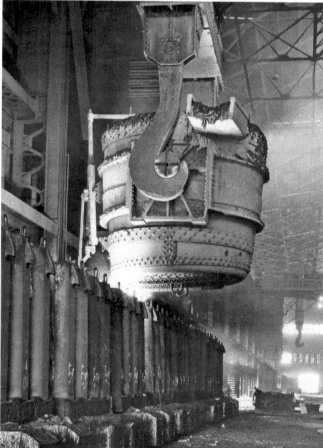

Above: U.S. Steel workers enter the mill's main gate entrance in the early days. *U.S. Steel Gary Works Photograph Collection.*

Left: An overhead bucket transports steel through the mill. *U.S. Steel Gary Works Photograph Collection.*

Drawn Steel Company. Thousands of jobs were wiped out, and millions of dollars in property taxes to the city were lost, among other related economic benefits that have disappeared in Gary.

This has proved a hard lesson to a city born from steel with a reputation forged, in many ways, by unforeseeable global market factors. Yes, John Tipton's ignorant assessment was obviously wrong about the city's promise and potential. But so was Elbert H. Gary's arrogant prediction of its sustainability and future. Most of the "good schools, churches, law and order" in Gary the city have succumbed to the same fate as Gary the man.

"Magic Industrial City"

I see a city rise as if by magic, in proportions vast and splendid.
—Indiana governor Frank Hanly, 1907

"Urban experiment."

This novel term was often used to describe the city of Gary in its infancy, quickly attracting the attention of several prominent architects of the day—Frank Lloyd Wright, George Maher and Son, J.T. Hutton, John Eberson, Holabird and Roche and George and Arthur Dean, among other notable names. But how many of their fine works are still standing? As Gary eventually grew to fifty-four square miles, boasting roughly the same number of ethnic groups, the young "Magic Industrial City"—named for its rapid growth—offered high hopes and grand expectations. Talented architects saw a chance to enhance their names, expand their work and make a lot of money along the way. They were no different than many outsiders who converged in Gary at the intersection of Rare and Opportunity.

Fueled by new jobs at U.S. Steel and a population boom, topping 100,000 by 1930, the city's rich architectural heritage built its first foundations. Commissions by Chicago-area and nationally known architects filled the streets, properties and neighborhoods. This served as a lasting microcosm for the styling of that era, according to Christopher A. Meyers, the city's former director of planning and development from 2005 to 2012. "An analysis of the city shows many modern forms of construction techniques, architectural styles and design ideologies," Meyers writes on his website, which chronicles the city's architectural beginnings. "In comparison to other nearby cities, Gary possesses a noteworthy bastion of terra-cotta ornament, early examples of reinforced concrete structures—some of which are loosely

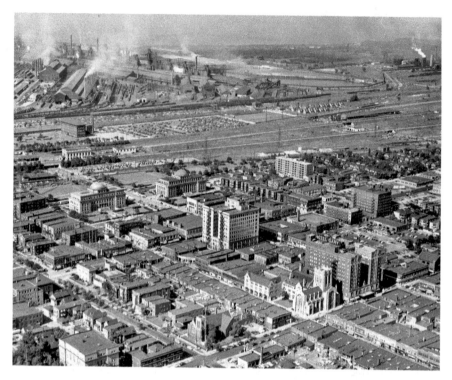

Aerial view of the city, circa 1950, with U.S. Steel in the background. *Calumet Regional Archives.*

modeled after Thomas Edison concrete patents—prime examples of Prairie School buildings, forward-thinking Worker's Housing, a diverse mixture of American building styles, and rare urban design scenarios."

The website's mission aptly illustrates that Gary still possesses an architectural collection worthy of preservation, said Meyers, who owns several blueprint copies of the architects' original designs.

In 1906, Gary's first cast-stone building was erected: the Gary State Bank on the southwest corner of Fifth Avenue and Broadway. That structure was later razed in 1929 for the building that still stands. That same year, the Chicago architectural firm Dean and Dean was commissioned by the Gary Land Company to supply residential designs for its First Subdivision. That first development still makes up the downtown area, though much of it is in ruins. Numerous Dean and Dean designs were constructed using different materials and types: duplexes (two units), quads (four units), row houses (six units), apartment buildings (two to four units) and single-family homes.

"All of these designs featured a Prairie School style of architecture," Meyers writes. "The exterior's first floor was masonry while the second floor possessed an application of stucco. The denotation of the first floor from the second floor through the use of materials is a signature of Prairie School architects and of the movement's design ideologies." The majority of its designs sported gabled and multi-gabled roofs. For the duplex and quad designs, roofing was ingeniously extended over the main entry, creating a covered porch. "Each of the designs also had a fireplace, built-in bookcase or shelving, plus elegant millwork," said Meyers, who identified previously undocumented works by George and Arthur Dean, George W. Maher and Son and Frank Lloyd Wright. As the city annexed nearby communities that preceded its own existence—Miller and Aetna, in 1918 and 1924, respectively—Gary's downtown area blossomed with new buildings.

In 1924, free grass seeds were even given out to homeowners to spruce up the new industrial city. "The city is going to clean up the front yard, mow the lawn, and trim the hedge," the *Post-Tribune* newspaper stated on March 19 of that

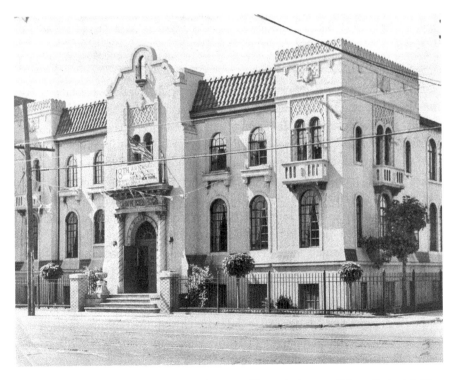

The Union Español "Spanish Castle" at 700 West Eleventh Avenue. *Calumet Regional Archives.*

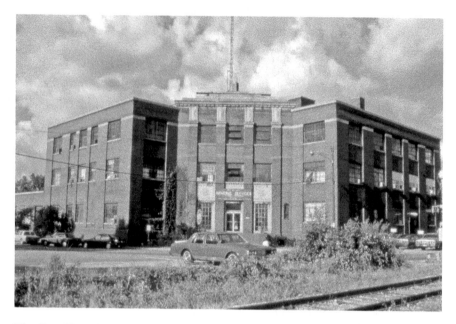

The Gary Heat, Light and Water Building was one of the original buildings commissioned by U.S. Steel and designed by architect George W. Maher. *Christopher Meyers collection.*

year. The gesture by city officials was more about planting the seeds of promise than about residential landscaping. The legendary architects served as the first farmers for this movement. Maher and Son, for instance, was commissioned for the design of a new Elks Temple. "Of all Maher buildings located within the city, this structure is truly the most Prairie School oriented," Meyers says.

The initial temple, at Sixth Avenue and Washington Street, quickly outgrew the organization's needs. The new building's second- and third-floor windows are punched into the building's envelope. A cresting element originally adorned the building but was removed in the late 1940s.

"Originally the main lodge entry had a set of rectilinear wall sconces that were typical of Maher's hand," Meyers writes. When the Elks left the building, it became the H. Gordon and Son department store, a longtime retail fixture in the city. A fire later gutted the building, destroying all interior elements designed by Maher. After the store closed, the building housed the Lake County Welfare Department before the agency later moved into the former Sears Roebuck and Company building on Broadway.

In 2015, the Elks Temple is vacant and destroyed, barely standing and housing only vandals and gapers. It is only one of many structures with a

similar fate, including the doomed Gary Heat, Light and Water Company at 900 Madison Street.

Also designed by Maher (just before he took his life in 1926), this steel-framed, precast concrete structure "shows U.S. Steel did not skimp during the prosperous 1920s," according to Indiana Landmarks, a nonprofit organization fighting to defend architecturally unique, historically significant and communally cherished properties.

"Exterior ornament includes pilaster capitals, cartouches, spandrel panels, dentils, and massive exterior lantern-like light fixtures. The structurally sound building retains original terrazzo floors, plaster details, wood moldings, and a semi-elliptical staircase," the organization states.

The city's general services department occupied the warehouse-type building for many years but abandoned it the 1990s. In 2012, the city targeted it for demolition, another eyesore in a city of black-eyed buildings. Three years later, it still stands, looking like a deeply wounded prizefighter long past his prime. The hulking structure was recently labeled as one of the

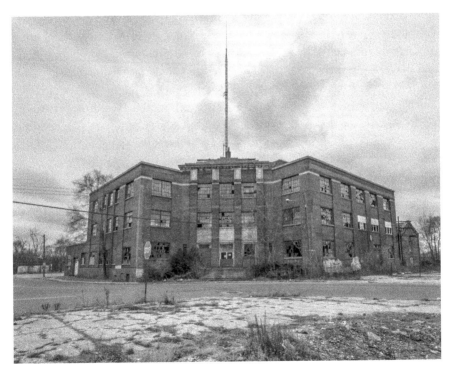

The Gary Heat, Light and Water Building, pictured here in 2014, awaits the same fate as thousands of abandoned buildings in the city. *Cindy Bean photography collection.*

ten most endangered buildings in Indiana, but it's down for the count, yet another technical knockout for a city on the ropes.

Many other historic buildings are standing on their last legs, lost in the fight for preservation but not entirely gone. This long list includes the Gary Schools Memorial Auditorium, Union Station, City Methodist Church and the Ambassador Apartments.

In their heyday, these structures were featured on historic postcards, which served as the social media of their day. Postcards today are generally considered as "kitsch vacation items," as Meyers notes; they offer visual reference points of yesteryear for researchers and scholars. They also help illustrate a building or site during a specified time period. Some postcards remain the sole form of photographic documentation and represent all that's left of these architectural wonders.

Through the decades, every type of building, structure and organization has been abandoned in Gary, from civic offices and old churches to extraordinary schools and ordinary shops—store after store, theater after theater, bakery after bakery, block after block. Up to ten thousand homes and residential constructions also have been long abandoned while awaiting demolition. It should be noted that few, if any, major buildings were constructed after the 1920s. Not even during the boom of the 1950s when so much growth took place around the country. The buildings that survived are almost one hundred years old, and they look it. "This is ancient by American standards, unlike in Europe which rebuilt many of its buildings that were bombed out in World War II," said region historian Ronald Cohen. Although preservation is "alive and well" throughout Indiana, Cohen noted, unfortunately it's not in Gary. "So much lost and still so much to save," Cohen said.

One of the most notable tenements is the vacant and deteriorating Ambassador Apartments at 574 Monroe Street. Opened in 1927 and designed by architect William Stern, the eight-story, sixty-eight-unit complex first catered to U.S. Steel mill executives. It was extravagantly trimmed in sculptured terra cotta, boasting detailed housing amenities far beyond those for the mill's other workers. Quite simply, it was the finest and fanciest of its day.

Over the course of time, the apartment building reflected the city's zenith as well as its demise, a towering barometer of Gary's rise and fall. In the 1960s, it dragged its feet to racially integrate its tenants. In the '70s, it was converted to low-income public housing. In the '80s, it was condemned and then converted into a de facto dwelling for the homeless, the mentally ill and the addicts of the downtown neighborhood.

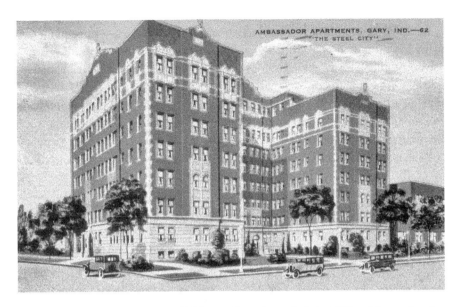

The Ambassador Apartments, at 574 Monroe Street, were built in 1927 and featured posh amenities for the city's high society. *Christopher Meyers collection.*

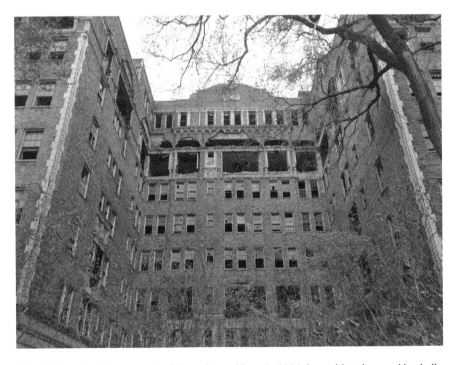

The Ambassador Apartments building, pictured here in 2014, is awaiting the wrecking ball after being abandoned for a quarter of a century. *Author's collection.*

In the '90s, a community development group planned to resuscitate the dying building with help from a group of investors. The joint venture would use grant funds, tax breaks and months of promises to turn it into a renewed housing project with commercial space, retail offerings and even two family-sized penthouses on the top floor.

The project never panned out, another failed promise in a city infamous for pointing the finger of blame in every direction.

The abandoned apartment complex is littered with trash, vandalized by graffiti and barraged by nature. Crumbling bricks topple from the once pristine walls, plunging to the ground below. At one point, parts of Sixth Avenue had to be closed to avoid danger to passersby. Demolition could cost up to $800,000, according to city officials, but grant money is needed. The public treasure went from a public housing eyesore to a public safety hazard.

The Wilbur Wynant home, designed by architect Frank Lloyd Wright, was destroyed by fire in 2006. *Christopher Meyers collection.*

The architectural genius Frank Lloyd Wright designed two homes in Gary, one located at 669 Van Buren Street and the other at 600 Fillmore Street. The former still exists, standing out like a white rose in a garden of weeds, a small satellite dish sprouting oddly from its roof. The latter Frank Lloyd Wright work faced a fiery fate. It was known as the Wynant House, built in 1916 for Wilbur and Etta Wynant by the General Construction Company. The home was a rare example of an American System-Built home, one of eight known Wright commissions in the state

and the last residential example built in Indiana during Wright's Prairie period, Meyers says.

"It was a stucco residence possessing a flat roof with projecting eaves, exterior inset banding elements, a front veranda, a rear entryway and garage, and two distinct styles of casement windows," he writes on his website.

The first floor was defined by a living room with a centrally located fireplace (an established Wright design element), dining area, kitchen and garage. Directly behind the front room's fireplace, a doglegged staircase allowed interior circulation to the garage, basement and second floor. That floor showcased three bedrooms and a bathroom, with a nod to the future. However, it didn't make it to 2010. "The Wynant House is a casualty of location and time. This house reflects what has transpired in Gary and many other urban cores throughout our nation," Meyers writes. "During the great flight of economic classes from the cities to the suburbs, from the 1960s to the 1980s, many historic urban neighborhoods were simply left behind."

The Wynant House, abandoned in the late 1970s, could have been rescued if it was located in a more affluent neighborhood or possibly in a city where historic preservation and urban land conservation policies were enacted, Meyers notes. In January 2006, an overnight fire gutted the house. Its owner boldly stated he would rebuild the fabled house but to no avail. Three years later, the city razed it, labeled as another public safety hazard. There is not a single trace of the home. Gary lost another significant portion of its architectural and cultural heritage.

In the city's early days, the downtown business district was not the only area getting attention from notable architects. In 1921, along the lakefront in Miller, Maher designed the Bathing Beach Pavilion, which opened in the summer of the following year. Maher specified Hydro-Stone, a form of cast-concrete block to mimic white Georgian marble, a cost-effective alternative. The facility was a hybrid of modified Greek and Prairie School architecture, featuring two wings: one for men, the other for women. The upper level served as a picturesque promenade to view the lake.

Three years later, Maher's recreation pavilion was constructed, finishing the planned two-pavilion aspect of Marquette Park. Both pavilions still exist but were endangered for many years until rehabilitated for new generations of residents and outsiders alike. The same fortune cannot be said for countless other designed structures from the early twentieth century. Within the past few decades, urban renewal, vandalism, planned demolition and the lack of historic resource management has conspired to turn Gary into a

city of ruins, much to the chagrin of preservationists, such as Meyers, who earned a master's degree in historic preservation at the School of the Art Institute of Chicago.

"These designs should be brought back into use and saved for posterity," he insists. "The unique architectural character, noteworthy use of materials, and as being rare examples of a well-known architectural firm should illustrate the importance of these designs."

Ideally, yes. Realistically, no.

As this book will explain in the following chapters, Gary's "urban experiment" imploded in its own laboratory, causing urban decay, racial unrest, political upheaval, white flight and the loss of more than half of the city's peak population. Simply put, the city's magic has been lost, and every administration has been promising to pull a new rabbit out of an empty hat.

PIONEERING SCHOOLS TO HARD LESSONS

Seize the moment of excited curiosity on any subject to solve your doubts; for if you let it pass, the desire may never return, and you may remain in ignorance.
—William A. Wirt

Of all the progressive and nationally renowned high schools that Gary once boasted to the world like rare diamonds, one jaded gem still remains from the city's early days. Yet it does so with an asterisk or, more to the point, a controversial hyphen. The Wirt-Emerson Visual and Performing Arts High Ability Academy is still in operation, though William A. Wirt's fingerprints are barely legible. Located in the Miller section of the city, it was built in 1939 in honor of Wirt, the school corporation's first superintendent and educational pioneer.

In 2015, the school with his name housed the Emerson Visual and Performing Arts Academy, though few Emerson graduates of yesteryear will ever claim it as theirs. To them, their beloved Emerson High School is long dead, the victim of neglect or murder, depending on whom you ask. Regardless, the shockingly sad crime scene remains at its original address on Seventh Avenue and Carolina Street.

It is literally a shell of its former glory, still standing but now abandoned, vandalized and left for dead. Its historic doors were shuttered for good in 2008, just a year before its one-hundred-year anniversary. Inside, it is

Right: William A. Wirt, the city's first schools superintendent, created the progressive "work, study, play" model for students, widely adopted in other cities. *Calumet Regional Archives.*

Below: Emerson High School opened in 1908 as the first school in the nation to fully incorporate William A. Wirt's "work, study, play" educational platform. *Christopher Meyers collection.*

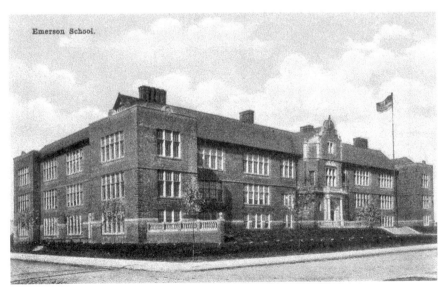

Emerson School.

completely trashed, but strangely, some rooms remain intact with glossy textbooks on the dusty shelves. It is as if a nuclear holocaust took place within the massive building and everything suddenly stopped in its tracks. Graffiti from vandals now serves as its tombstone epitaph. Chalk writing on one classroom blackboard says it all: "Why doesn't anybody care?"

Years earlier, mold had a death grip on the aging structure, and its antiquated fixtures could no longer withstand Father Time and Mother Nature. The city's ever-shrinking population gave birth to fewer students, and a slashed tax base and a decimated school budget only contributed to the school's death knell. Though Emerson served admirably as a highly successful magnet school during its twilight years, housing memorable classes for thousands of students in the visual and performing arts, the closing curtain came down in 2008. Another heyday came and went before its final bow. Its desolate property is now littered with broken windows and shattered recollections from its many graduates.

"I remember the pipes—the pipe fence in front of the school—where the guys always hung out," recalled Mickey Manoski, a 1959 Emerson graduate.

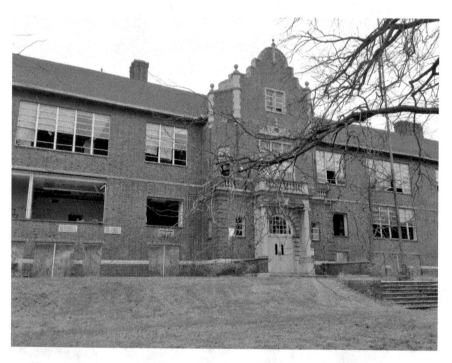

Emerson High School closed its doors for good in 2008. Photo taken in 2014, as it barely stands today. *Author's collection.*

"We girls tried to avoid walking by them because of their catcalling while trying to show how cool they were. One day, the girls were determined to hang out on the pipes. We got a kick out of it, but our comments were a lot more tame," she joked.

Named after poet Ralph Waldo Emerson, the school was the first kindergarten through twelfth-grade educational facility in the city. (For the record, the first school in Gary was named Jefferson, opened in 1908 inside a structure built by the Gary Land Company. Wirt didn't like it or its regressive educational design.) Emerson graduates of fame include actor Karl Malden (born Mladen Sekulovich) and NFL star turned actor Alex Karras, among others.

In 2014, there were only two other high schools still in operation in the sprawling city—West Side Leadership Academy and New Tech Innovative Institute—plus a few charter schools, according to Gary Community School Corporation records. In all, roughly twenty schools have been closed—five in 2014 alone—to adjust to a slipping enrollment figure of roughly 7,500 students. Emerging charter schools have slashed public school funding from

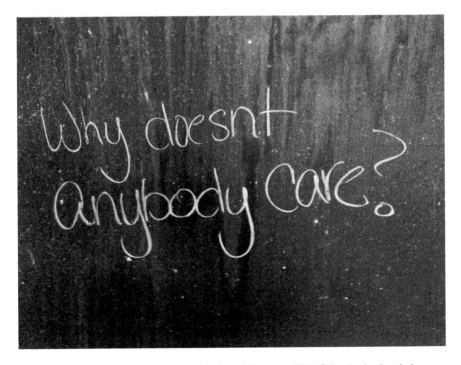

This classroom chalkboard inside the abandoned Emerson High School asks the obvious question. *Author's collection.*

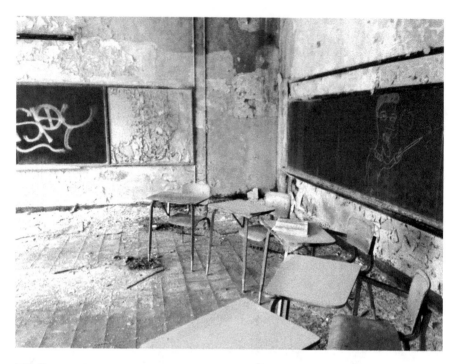

This Emerson High School classroom, in 2014, illustrated the haunting existence of a once proud and vibrant school. *Author's collection.*

the state, and property tax caps have cut a bleeding budget. Every school in the district needs renovations of some kind, yet there is no money to repair them. With a total deficit of $81 million, the Gary School Board voted in early 2015 to ask taxpayers to support a $51.8 million referendum. Other numbers are just as daunting: nearly 20 percent of the city's residents have not completed high school, and only 43 percent have some college experience or are college graduates—more than 10 percentage points below the national level. In early 2015, the school district announced plans to sell or lease four schools, including the closed-down Lew Wallace High School in Glen Park. Its fate is unclear.

In addition, only eleven elementary schools remained open in 2014, including Marquette Elementary School in Miller. Roosevelt High School was taken away from the school district by the Indiana Department of Education. IDOE designated the district as high risk due to unsatisfactory academic performance and fiscal instability

All the other schools are gone, either razed or abandoned, with each one lost to various culprits—neglect, old age, politics, harsh realities of a

besieged city—victims of not enough pomp and too much circumstance. Horace Mann School, which took several years to complete, had its share of pomp and circumstance, graduating classes after eventually opening in 1927. Named for the country's father of public education reform, it was located on Garfield Street on the city's west side. Horace Mann stood out for its park-like design, with rolling hills, eye-catching lagoon and beautiful ravine, as well as a rock garden, large pond and bird sanctuary. Designed in classic Tudor style, its three buildings stood majestic amid the schools of its day.

One of its most famous grads was Tom Harmon, the natural-born athlete who later won the Heisman Trophy while playing football at the University of Michigan. Other notable grads include Joseph Stiglitz, valedictorian of his class, who won the 2001 Nobel Prize for Economics and the 2014 Daniel Patrick Moynihan Prize for his contribution to the public's understanding of "the sources and dire ramifications of economic inequality in America."

Horace Mann High School, shown here circa the 1950s, set a new standard for public schools by featuring landscaped hills, multiple gyms, pools and a man-made pond. *Calumet Regional Archives.*

Also, the world-class singing tenor James Eugene McCracken graduated from Horace Mann in 1944. The school housed and educated nearly 100,000 students over the span of three-quarters of a century. Its final bell sounded in 2004, and it suffers the same tragic fate of Emerson: there but not there. Its classrooms have been ransacked. Its halls have been vandalized. Its soul has been ripped out, another lost school in a lost school system.

The same can be said for Edison High School, Tolleston School and Roosevelt High School, whose famous alumni include actor Avery Brooks, NBA star Glenn Robinson and the older brothers of pop star Michael Jackson. The King of Pop's childhood home is just across the alley on, coincidentally, Jackson Street. Designed as the first—and only—high school built exclusively for blacks, Roosevelt is a shadow of its former self and former glory. Currently called the Roosevelt College and Career Academy, its historic legacy was recently recognized by being listed on the National Register of Historic Places not only for its Colonial Revival architecture but also for its importance in the city's black communities. It was their school, and everyone knew it.

The school also represented a symbolic yet dramatic shift in the racial chemistry of Gary's overall student body. It signaled a new chapter in the

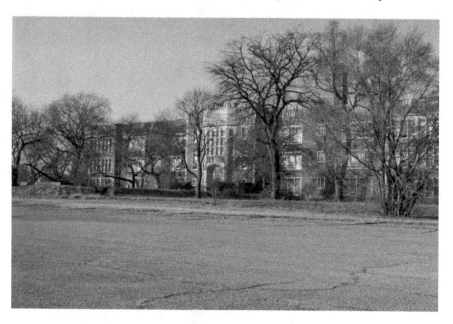

Horace Mann High School, shown here in 2014, produced Nobel Prize and Heisman Trophy winners and a world-famous tenor before closing in 2004. *Cindy Bean photography collection.*

book on black pride, too. "Panther Pride" became a war cry for its students, featuring a school and legacy they could call their own. Even in its current state, the school's graduates cling to their glory days there, as with most grads from other Gary schools that are no longer around.

However, the most notable of all the lost schools in Gary is Froebel High School, the second crown jewel of the school corporation, named in honor of the German educational philosopher Friedrich Froebel. Its only remnant these days is a historic marker erected on its once spacious campus.

Opened in 1912, between Thirteenth and Fifteenth Avenues and Madison and Jackson Streets, the school truly realized all of Wirt's dreams. Historians can only wonder how Wirt would react if he found out about its demise, as well as about the city's struggling educational system in the twenty-first century. An Indiana native with an eye on the future, Wirt's progressive philosophy of "work, study, play" became the mantra for all Gary schools during his lifetime and beyond. When, in 1906, he found out about a new

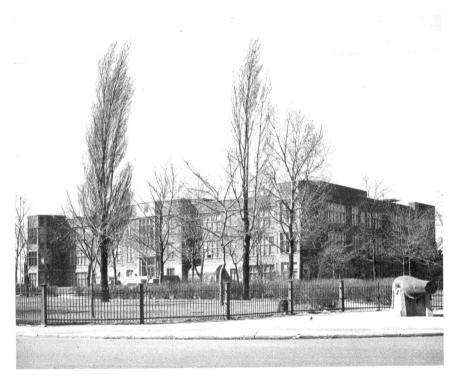

Froebel High School, opened in 1912, was deemed Gary's monument to racial integration and progressiveness before being closed in 1977, neglected and razed nearly three decades later. *Christopher Meyers collection.*

steel town being created from scratch by U.S. Steel, he visited with town officials and explained his innovative concepts. It became the "Gary Plan" for the city's schools, which eventually became a national model.

Wirt's goal was to prepare each student and every aspect of their development, from academics to athletics, from kindergarten to twelfth grade. Oddly, instead of grooming students strictly for a life in the steel mills, where thousands of Gary graduates eventually found work, Wirt's educational factories groomed them for life. He believed in "learning through doing," an idealistic lesson plan at the turn of the twentieth century. His "platoon system" encompassed most of the school day, keeping many kids busier than their parents. Froebel's fifteen-acre campus showcased everything that Wirt imagined: a large auditorium, swimming pools, laboratories, gymnasiums, vocational rooms, music rooms, a public garden, playgrounds, a three-bedroom apartment and even a zoo.

Its designer, William Ittner, declared it a "splendid civic monument," and it attracted national attention for its then unheard-of progressiveness. Froebel became one of the first schools to integrate students, an immigrant hodgepodge of ethnicities, languages and racial diversity. It didn't necessarily work with the integration of black students, who were kept out of many activities, such as swimming in the same pool with other students. They were allowed to do so only the day before it was to be cleaned, according to news accounts.

In some ways, the school's grand experiment failed, illustrated by the racial volatility that eventually peaked in 1945. Hundreds of white high school students boycotted the school, prompting entertainer Frank Sinatra to visit the city to perform at the Gary Schools Memorial Auditorium. There, he chastised them for their actions, threatening to "lick any SOB" in the venue. They mostly ignored him, only attending to hear him sing, not give a lecture. Still, those students returned to school in November of that year. The racial tensions lingered for decades.

Fast-forward to 1977, when Froebel School finally closed, saddening thousands of former students. Although it merely reflected the city's woes of the time, the real heartbreaker came in 2005, when the iconic building was razed. Lost. Forever. Amid outrage and profound sadness, critics said that the school's demolition was a travesty against the spirit of historic preservation. Protests only delayed the inevitable, others said, prompting the question of which is worse, a razed school or a neglected one?

Nearly a decade after Froebel was removed from sight, it looks like a cemetery of buried recollections. The remnants of football goalposts and basketball backboards still stand on one side of the property, called Froebel Park. On the other side is a stone marker of the site's previous incarnation. Near the street, a

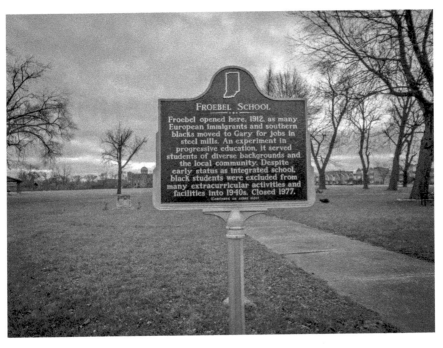

The historical marker unveiled in 2014 on the former grounds of Froebel School. As noted by state representative Vernon Smith: "Closing this school was the beginning of the death of this community." *Cindy Bean photography collection.*

newer historic marker was stoically placed on the school's former grounds. While serving to memorialize the site, it also served as a stake into the collective heart of all the proud Froebel graduates. In May 2014, Indiana state representative Vernon Smith took part in the marker's dedication ceremony. The 1962 graduate solemnly summed up not only the loss of the school but, more telling, the impactful loss of all the lost schools in the troubled city as well.

"Closing the school was the beginning of the death of this community," he said.

LOST PEOPLE AND COMMUNITIES

FAMOUS NATIVES FLEE

Gary, Indiana…that's the town that knew me when.
—Music Man, *Meredith Willson*

What do an NFL star, an Academy Award winner, a boxing champ, a world-class astronaut and the King of Pop all have in common? Add to this impressive list an acclaimed opera singer, a Heisman Trophy winner, three Major League Baseball players, a heroic shutterbug and not one but two Nobel Prize winners. All of them call Gary their hometown, though none returned to live in the city, not permanently, anyway. The city's rich history also lies within its famous citizens, each one eventually lost to the waiting world. From Johnny Bushemi, Tom Harmon and Michael Jackson to Lee Calhoun, Fred Williamson and Glenn Robinson, the list is lengthy, but the people are long gone.

The Boy Who Would Be King Comes Home

Gary's most famous son, Michael Jackson—the self-proclaimed "King of Pop"—came into the world with very meager beginnings. The eighth child of Joe and Katherine Jackson was born on August 29, 1958. His father worked at U.S. Steel, and the entire Jackson family, eleven in all, lived in a

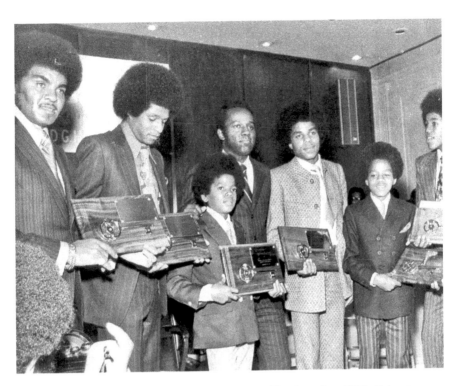

The Jackson family poses with Gary mayor Richard Hatcher, circa 1970. *Calumet Regional Archives.*

cramped two-bedroom house on, coincidentally, Jackson Street. Although Michael's parents had aspirations to be professional musicians, Joe noticed his sons had musical gifts he never possessed. The brothers Jackie, Tito, Jermaine, Marlon and a very young Michael formed the Jackson 5. Without realizing it at the time, the city gave birth to musical history.

Under Joe's harsh discipline and endless rehearsals, his talented sons gained fame, and in 1969, the family relocated from the Steel City to Tinsel Town. The young pop group became known around the world, with their own Saturday morning cartoon show at one time. At the tender age of thirteen, Michael branched off for his solo career and rarely glanced back at Gary.

His mega-selling album *Thriller*, released on November 30, 1982, dramatically changed the music industry. It's still the top-selling album of all time with an estimated 110 million copies sold. Michael's illustrious career spanned decades and broke world records, and he continues to be the most awarded recording artist in pop music history. No other artist has seen

such fame and acclaim. Controversy, however, shadowed Jackson's career, from his questionable marriages and ever-changing appearance, to his odd fascination with all things childlike, including the Disney-fashioned theme park on his property. Most damning to his career were ongoing litigation, rumors and innuendos regarding his sexual misconduct with minors. He continually rose above it all.

In June 2003, Jackson paid a rare visit to his boyhood home at 2300 Jackson Street. He gingerly walked through the home he left behind more than thirty years earlier. He did so amid throngs of die-hard fans, over-the-top fanatics, tight-lipped security guards and endless media outlets. Jackson was dressed in black with dark sunglasses. His large entourage blanketed him, sporting cellphones and a huge black-and-white umbrella over Jackson the entire time. The "Michael Jackson tornado," as media described it, had a circus atmosphere while waiting for the single-gloved, moon-walking enigma to arrive.

"Tito slept there, Marlon slept there," Jackson told distant relatives in the living room of the single-story flat, which is slightly larger than a two-car garage. The boy who would be the King of Pop told relatives that his family "rehearsed, rehearsed and rehearsed" all through his childhood—or what there was of it.

Though he left Gary with his family, his boyhood home later became ground zero for everything and anything involving the Jackson family. Anniversaries, birthdays, album releases—the locals visited the home to celebrate their native son and his royal family. The family only occasionally returned to the city, and usually under the cloak of secrecy. For most longtime residents in the old neighborhood just behind Roosevelt High School, the Jacksons were gone for good, lost forever. It was a hard lesson for the city to learn.

Jackson died in June 2009, from acute propofol and benzodiazepine intoxication overdose, administered by his so-called trusted doctor. His boyhood home quickly became the focal point to memorialize the fallen King of Pop. It also represented a symbolic grave site for a family that exhumed itself from Gary decades ago. The home attracted an eclectic menagerie of visitors, including die-hard MJ worshipers, genuinely sympathetic mourners, curious region residents and city officials presiding over the new media circus. Neighbors sold parking spaces on their lawns. Vendors hawked Jackson memorabilia. Fans wept in the streets over their loss.

In many ways, the small patch of corner property served as a microcosm of our pop culture world as well as a sociological experiment on public

Michael Jackson's boyhood home has been renovated and now serves as a shrine for the King of Pop. *Author's collection.*

mourning—how we grieve an infamous death, how we celebrate a famous life and how we take advantage of one, too.

A month after Jackson's death, a money-minded vendor announced the "King of Pop Hometown Bus Tour," offering to transport Jackson fans and curious guests to all of his boyhood haunts in Gary. The bus tour promised "never-before-told" stories from former classmates and childhood friends. It also promised treks to the corner store the Jackson family once shopped, Michael's former junior high school and the early venues where the Jackson 5 first performed. The thirty-mile, four-hour bus tour would cost only fifty-five dollars.

It never materialized, as with most things involving the Jackson family in their hometown. This includes the much-hyped Jackson-themed entertainment venue/museum attraction, to be located near the region's two major highways. Former Gary mayor Rudy Clay once announced that there were "major players" involved with the project and a public announcement would be made. It never happened. Some city officials blamed a previous mayor. Others blamed Northwest Indiana officials. Once again, politics polluted the promise of better things in the Magic Industrial City.

At the long-abandoned Palace Theater on Broadway, a drab façade covered decades of failed promises. Its hopeful yet misleading marquee offered another empty promise: "Jacks_n Five Tonite," with a dangling F threatening to follow the suicidal O.

From the Streets of Gary to the "Streets of San Francisco"

In the mid-1970s, the tagline "Don't leave home without it" became part of the American lexicon and pop culture jargon, thanks to Mladen George Sekulovich. Known more commonly as Karl Malden, the budding film star was raised in Gary, graduated from Emerson High School and later worked

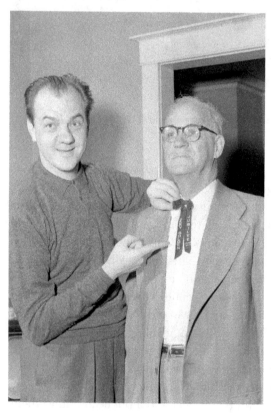

in the steel mills for a few years. Although the mill paid well for a hard day's work, Malden always knew he wanted to try acting as a profession. No, he didn't have traditional Hollywood-handsome features, but he had a mill truck of talent. This led him to several high-profile roles, including *On the Waterfront*, earning him an Academy Award in 1951. Malden often paid homage to his Serbian heritage by using his real surname, Sekulovich, to name many of his fictional characters in movies and television. Though he tends to be most notable for his famous American Express catchphrase, his seventy-year career best portrayed the American dream.

Karl Malden jokes with his father when Karl returned to Gary for the city's Golden Jubilee celebration in 1956. *Calumet Regional Archives.*

Gary's Man of Steel

Superman was not the only "Man of Steel" to anyone living in Gary in the 1940s and '50s. Anthony Florian Zaleski shared the same nickname. He didn't run faster than a speeding bullet, nor could he fly. But the boxing champ who became known as Tony Zale could withstand punch after punch in the ring. Zale was born on May 29, 1913, graduating from Froebel High School and working in the steel mills to make ends meet. At the time, being a steelworker was the path that most Gary kids took. You worked in the mills. You didn't work your opponent's body, like how

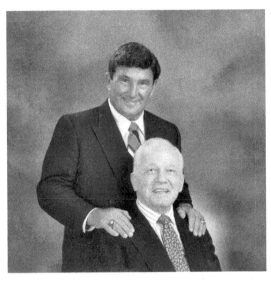

Boxing legend Tony Zale (seated) and NFL coach Hank Stram are two of the city's most popular sports legends and appeared regularly at the annual Gary Silver Bell Banquet to honor high school athletes of Polish heritage. *Calumet Regional Archives.*

Zale became distinguished. The soft-spoken Polish steelworker became a boxing legend, called one of the one hundred greatest punchers of all time, according to *Ring* magazine. His record was sixty-seven wins (forty-five knockouts), eighteen losses (five by knockout) and two draws. Gary's Man of Steel was a two-time world middleweight champion, best remembered for his three bouts over a twenty-one-month period with Rocky Graziano for the crown. These fights were the most brutal middleweight championship matches of all time. Zale won two of them. He remained a publicly quiet and deeply private man, returning to his blue-collar life after his stellar boxing career. He returned to Gary and later lived in nearby Portage, where he died in 1997 at age eighty-two.

Matriculating from Gary

The word "matriculate" can be found in any dictionary, but Lew Wallace High School graduate Henry Louis "Hank" Stram made it his own. Born in

1923, the NFL coaching legend quarterbacked a successful head-coaching career for the Kansas City Chiefs, winning three AFL championships and Super Bowl IV in 1969. Little did anyone know, Stram also is partly responsible for the introduction of Gatorade to the NFL. He had a close relationship with University of Florida coach Ray Graves during the sports drink's early development. Stram died on the Fourth of July, 2005, an All-American for eternity.

His Friends Called Him "One Shot"

John Bushemi's haunting last words, "Be sure to get those pictures back to the office," became his legacy. Bushemi was a talented young photographer who worked for the *Post-Tribune* newspaper in the late 1930s, known for his sports shots and quick-trigger ability to capture history in just a single shutter click. He was eager. He was affable. He was fearless. He was the seventh of nine children, coming to Gary at age twelve and attending Lew Wallace High School in the city's Glen Park section. His friends called him "One Shot," and his country soon called him U.S. Army staff sergeant John Aloysius Bushemi. He served as the poster child for the American experience during his era: clean-cut looks, a boyish innocence and determined to serve Uncle Sam.

"Johnny Bushemi is said to have had more World War II photographs published in American magazines than any other Army photographer," stated a compiled biography in the Indiana Journalism Hall of Fame. On February 19, 1944, Bushemi was hit by mortar shell shrapnel while shooting the American landing on Eniwetok. Most journalists retreated from the front lines but not Bushemi, who never lost his zeal for the best shots. "Where's my camera!?" he yelled after getting shot by the enemy. A colleague saw Bushemi's gaping neck wound and shattered leg. While Bushemi was carried away on a litter, Bushemi's camera was placed next to him. That's when he uttered those famous last words. He died hours later aboard a navy transport ship, according to the 2004 book *One Shot: The World War II Photography of John A. Bushemi* by author Ray Boomhower.

A *Post-Tribune* story captured his memorial service on March 3, 1944:

> *Under a gray and lowering sky which itself seemed to verge on weeping, hundreds of those who knew and loved Johnny Bushemi as an elfin boy, as a genial young man eager to make his mark in the world and as a*

gallant soldier impatient to give his all to his craft and his country, filed into St. Mark's Church this morning to bow their heads in memory of him.

"Mongo Only Pawn in Game of Life"

Alex Karras is remembered for many things in life but never for being a pawn. Born in 1935, Karras quickly stood out among his peers at Emerson High School as a four-time Indiana All-State football selection. Karras had his choice of colleges to play football, choosing the University of Iowa, where he helped the Hawkeyes win the Rose Bowl in 1956. After college, and before playing in the NFL, Karras signed as a wrestler, but it never panned out. Eight days later, he was drafted by the Detroit Lions and quickly became one the most dominant defensive tackles in the

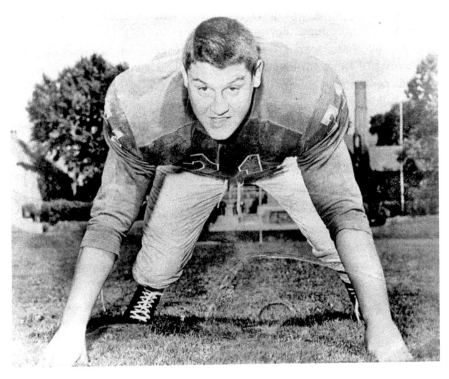

Alex Karras, an Emerson High School graduate, played football with the Detroit Lions before becoming an actor, noted for his role as "Mongo" in the 1974 comedy *Blazing Saddles*. *Calumet Regional Archives.*

league. Karras played with the Lions for twelve seasons until being traded to the Los Angeles Rams. Living near Hollywood while his football career came to a close, Karras tackled acting for his next profession. His most famous role came as "Mongo," the scene-stealing cowboy who punches a horse in the 1974 film *Blazing Saddles*. Karras also appeared in numerous TV commercials, sporting events and other entertainment shows. In the 1980s, Karras and his wife, Susan Clark, starred in the successful series *Webster*. Karras died on October 10, 2012, but not before being inducted into the Indiana Football Hall of Fame and into the hearts of proud Gary residents.

Expressway to the Moon

Although Frank Borman moved from Gary with his family during his youth, he left an indelible mark on the Calumet region. At age fifteen, he learned how to fly and never stopped soaring in life. His skyrocketing career took him around the world and, more notably, out of this world. Borman's accolades soared to infinity and beyond, from being selected for the Aerospace Research Pilot School in the early 1950s to the position of assistant professor of thermodynamics and fluid mechanics at West Point. In 1962, Borman was chosen by NASA for the agency's second astronaut group as the Command Pilot for Gemini 7. Borman, along with James McDivitt, Neil Armstrong, Gerald Carr and Jon Engle, flew Gemini 7 in December 1965 for a record-long endurance of a fourteen-day flight. In 1969, Borman became a special advisor to Eastern Airlines, eventually becoming the airline's chairman of the board. He retired in 1986, moving to Montana with his wife while making appearances for NASA-related projects and speaking engagements. As a lasting tribute, a long stretch of Interstate 80/94 in Northwest Indiana is named in his honor, the Borman Expressway. Each day, thousands of motorists utter his NASA-linked name without knowing they're driving straight through his hometown.

Singing His Way to a Worldwide Stage

World-renowned operatic tenor James McCracken sang his way to the top, from church choir hymns as a child and stage musicals at Horace Mann High School to sold-out performances at the Metropolitan Opera. Born in

Gary in 1926, he began his singing career in the U.S. Navy during World War II. Blessed with a deep, distinctive voice, McCracken became one of opera's principle dramatic tenors in his day. At age sixty-one, he gave his last performance at the Met, just weeks before his final curtain call on April 29, 1988. The *New York Times* honored his memory by stating that McCracken was the "most successful dramatic tenor yet produced by the United States." His hometown has been singing his praises ever since.

Gary's Nobel Prize Winners

Gary natives Paul Samuelson and Joseph Stiglitz each hold the distinguished honor of having been awarded the Nobel Prize for their work in economics. Both were born in Gary—in 1915 and 1943, respectively—before leaving for brighter futures elsewhere. Samuelson's family relocated to Chicago in the 1920s, where he soon made a name for himself. He is widely regarded as the most important economist of the twentieth century and credited for the emergence of the Massachusetts Institute of Technology, or MIT. His vast work in economics still provides the foundations for industry advancement to this day. Stiglitz was raised in Gary and was the 1960 Horace Mann High School valedictorian. He later became assistant professor of economics at Yale University, where he earned tenure at the age of twenty-seven. Over his prolific career, Stiglitz has produced many publications, changing how the world understands economics. On occasion, he has returned to Gary to lecture at Indiana University Northwest and other universities.

Miller's Hometown Slugger

Ron Kittle labored in the local steel mills before toiling in the big leagues at age twenty-five. Born in 1958, the Wirt High School graduate first played Major League Baseball for the Chicago White Sox, hitting thirty-five homeruns and one hundred RBIs in his Rookie of the Year season. The Sox won ninety-nine games that year and enjoyed their first playoff appearance since 1959. Kittle soon became famous with fans for his line-drive rooftop homers at the old Comiskey Park. Kittle, who still lives in Northwest Indiana, played ball for several other teams during his career, including the New York Yankees, but he will always be considered a "South Sider" to Sox fans and as a hometown hero to Gary fans.

Gary's All American

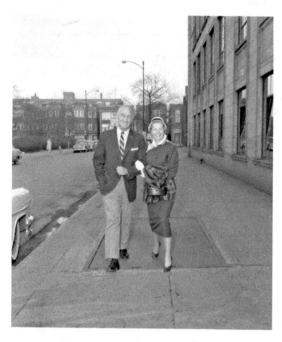

Gary native Tom Harmon, shown here with wife Elyse, was a Horace Mann graduate and a star college football player who won the Heisman Trophy in 1940. *Calumet Regional Archives.*

Some men were born to play sports. Tom Harmon was one of them. Born in Rensselaer, his family moved to Gary, where he graduated from Horace Mann High School in 1937. There, he left a legacy in sports excellence that has never been matched. He earned fourteen varsity letters, was twice named All-State football quarterback and, as a senior, won the 100-yard dash and 200-yard low hurdles in the state finals. In 1940, he again made a name for himself, this time at the University of Michigan, by winning the Heisman Trophy in his senior year. Harmon was the first pick of the NFL draft for the Chicago Bears, but he instead played for the New York Americans of the American Football League. He also served as a pilot in the U.S. Army Air Corp during World War II and later became a television fixture with commercials and sports commentary. In 1967, Harmon returned to his hometown to accept the Gary Old Timers Award at a well-attended banquet. After reminiscing to the crowd, he told them, "I thank Gary for a lesson in toughness." Harmon died in 1990, leaving behind a legacy of unparalleled sports achievement in college football, as well as in the city of Gary.

"Gary, Indiana, Made Me"

Actor, musician and director Avery Brooks graduated from Roosevelt High School before attending Indiana University, Oberlin College and Rutgers

Avery Brooks, best known for his role on the science fiction television series *Star Trek: Deep Space Nine* was born in Evansville. "But it was Gary that made me," he said. *Calumet Regional Archives.*

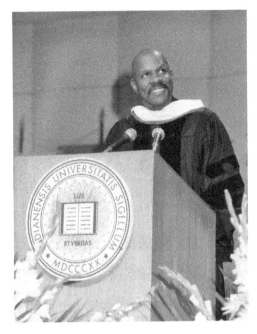

University, where he was the first black student to receive a master of fine arts degree for acting and directing. His successful television career includes *Star Trek: Deep Space Nine*, *Spencer for Hire* and its spinoff, *A Man Called Hawk*. Brooks also has performed on Broadway and hosted several documentaries while never forgetting his Gary roots. Throughout his career, he has always paid homage to his hometown, once proudly noting, "I was born in Evansville, but it was Gary, Indiana, that made me."

HUNKYTOWN FADES AWAY

Come to Gary—Become a factor in the building of the model city!
—Gary Land Company advertisement, 1907

They called themselves "Hunkies." They called me one, too.

The derogatory label was an ethnic slur against foreign-born, hardworking laborers who hailed from Central, South and Eastern Europe. The slur was likely derived from the term "Bohunk," referring to Bohemian-Hungarians who immigrated to this country for their shot at the American dream.

Legend says the slur first applied to coal mine workers in Pennsylvania before immigrating west to Gary, the new steel town that attracted thousands of foreign-speaking Hunkies to its dangerous mills along the lakefront.

Instead of finding out which European country these new immigrants came from, the American-born Garyites and others lumped together all the

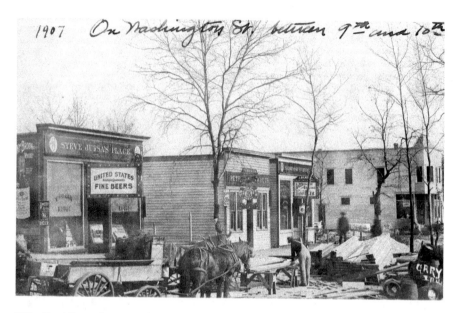

1907 On Washington St. between 9th and 10th

"The Patch" was the unregulated expansion of Gary in the early 1900s, attracting mostly poor, foreign workers and more than two hundred saloons and other disreputable establishments. *Calumet Regional Archives.*

foreigners. And called them all the same slur. It was easier. It was simpler. It was discriminative. Welcome to America.

"This is living, breathing, sweating, drinking, cursing, laughing, singing Gary," wrote Arthur Shumway, a former *Post-Tribune* newspaper reporter in 1929. This is when Gary's cultural mecca could be found on its south side, where most immigrants lived, played and drank with Old World abandon. This is where the smell of foreign cooking wafted in the air, where languages melted into one, where newcomers "just off the boat" felt more at home.

Still, the older Hunkies in Gary wore their ethnic slur with pride, including my father, Joe, and his father, George. As a kid, I remember my father jokingly calling us Hunkies in public. I wore that label with honor at Croatian picnics and Serbian festivals until I entered Gary schools, where it was used against me by blacks and other minorities.

I equated hunky with being prideful. They equated a similar slur, "honky," with being Caucasian, used to describe all whites. It was simpler. It was easier. It was Gary in the '60s and '70s. Considering I'm both a Hunky and a honky, I've been called both through the years. The older I get, the more I appreciate being called either one.

LOST PEOPLE AND COMMUNITIES

In the early twentieth century, most of the Hunkies of Gary lived in the section of the city south of Ninth Avenue. It was historically for the poor, uneducated immigrants who toiled in the mills. By stark contrast, the section north of Ninth Avenue was for well-heeled, upscale residents, mostly U.S. Steel executives, skilled workers and their families. South of Ninth Avenue, between Tenth and Fifteenth Avenues and bordered by Broadway and Madison Street, was a patch of land aptly and sadly called "the Patch." Essentially, it was the city's first ghetto.

The original architects of Gary built only half a city, historians agree in hindsight. The other half of the city, the Patch and beyond, was designed by a hardscrabble hodgepodge of flimflam entrepreneurs, rogue landlords and flat-out criminals. This small section of town reportedly boasted more than two hundred saloons, gambling joints and businesses of ill repute. It came to define the city for years to come. "Gary, whatever else, is a paradox," Shumway wrote in a sharply tongued 1929 essay. "It is busy. It is dull. It is modern. It is backward. It is clean. It is filthy. It is rich. It is poor. It has beautiful homes; it has sordid hovels. It has a past, but it has no traditions. It lies in the gutter and looks at the stars."

It's doubtful how many residents of "Hunkytown," including my ancestors, understood his reference to Oscar Wilde's timeless prose. It didn't much matter anyway. Regardless, Hunkytown is no more. Except in spirit.

My family came from the Tolleston section of the city, located on the west-central side, which predates even the notion of Gary. Founded in 1857 by George Tolle, it was mostly populated by German railroad workers and farmers. It also served as the primary settlement location before U.S. Steel came to town or, more to the point, before it created the town of Gary.

Gary soon annexed Tolleston, in 1910, at a time when the town boasted a burgeoning population of roughly seventeen thousand. More than half of those residents were foreign-born, and two-thirds of them were male. In time, many of those Hunkies infiltrated Tolleston, including my family. Fast-forward to 2014, when I took a slow cruise through that section of the city to find any remnants of my relatives' memories from their youth. There were few to find, I discovered. Possibly a home or two, but no other tangible brick-and-mortar memories to guide me through the past. Only elusive ghosts from the nearby Hunkytown.

Its last refuge was found mostly in the backroom of an old-style restaurant located on the outskirts of Gary. It was called the Country Lounge in Hobart, featuring a section of the joint adorned with a banner. It proudly stated, "Hunky Hollow." There, old-timers congregated to share drinks, Old World meals and reheated memories of yesteryear. It was quite simply the place to

be for Hunkies of any age and of any Central European ancestry. It was a home away from home.

There are still pockets of similar refuges within Gary for modern-day Hunkies. Mostly at bars and taverns, appropriately enough, with a respectful if not drunken nod to our collective past. But there are not many. Even the summertime Croatian and Serbian picnics from my youth have migrated to other towns and cities in the region. They, too, are fading away, if not being entirely lost forever.

Today, Hunkytown is no longer a physical location on a map but a hodgepodge of ethnic nostalgia. A hardscrabble "patch," if you will, of fond remembrances passed down to new generations of twenty-first-century Hunkies.

BLACK POWER, WHITE FLIGHT: POPULATION IMPLOSION

Our city is facing a bright future, if we can all come together.
—*Gary mayor Richard G. Hatcher, 1979*

White flight has been labeled as the main culprit for Gary's population exodus in the 1960s, '70s and '80s, when tens of thousands of white residents fled for other communities. But what caused the white flight? Black power? White fear? The grayness of a shrinking steel industry? As with most issues related to race relations in Gary, it depends on whom you ask.

Blacks have always been residents of Gary, from its earliest days, helping to build U.S. Steel's plant and the city's first foundations. In 1910, roughly four hundred were counted as part of the rising population, many of them living in "the Patch," the city's first ghetto. Most experienced the same racial barriers and discrimination they faced in southern states.

It should be noted that during this time period and into the early 1920s, Indiana had the largest Ku Klux Klan ranks outside the Deep South, though they posed in public as "defenders of patriotism, morality and clean government," James B. Lane writes in his 2006 book *Gary's First Hundred Years: Steel Shavings*, volume 37.

In July 1921, after earlier praising the KKK as a "bulwark against anarchy," the *Gary Post-Tribune* newspaper questioned the group's principles, asking, "How is it possible to sell such a collection of tomfoolery, cajolery, hate, suspicion, bunkum, rot, idiocy and un-Americanism to the American people?" It turns out that it was remarkably easy to do with a willing populace. But the about-face

editorial did little to curb the mistreatment of blacks by whites in a young town on the brink of national notoriety. "Gary's first African-American residents suffered from substandard housing, job discrimination, inferior educational opportunities, inadequate hospital and recreational facilities, and inequitable law enforcement procedures," Lane writes.

Gary historian Dolly Millender agreed, noting that black newcomers did not find the city "a land of milk and honey, but instead found ugly prejudice." They came to Gary in droves anyway, especially during the World War I boom between 1914 and 1918, swelling Gary's black population, Lane writes. By 1920, the total population jumped to fifty-five thousand. Since those early years, racial unrest has been woven into the quickly inflammable fabric of the city as citizenry numbers steadily rose.

The section of the city now known as Midtown became the center of the black community. By the 1950s and '60s, when integration seeped into Gary, many black residents began moving out of Midtown and into other sections of the city. The migration was often met with opposition from white homeowners and business leaders. One example took place in 1963 when a black teacher bought a house in the Glen Ryan subdivision of Miller, where I was raised in my youth. According to the *Gary Crusader* newspaper, a group of white men threatened to firebomb the house, followed by dozens more neighbors protesting against the teacher's choice of location for her new home. A day later, fearing for the safety of her live-in eighty-five-year-old mother, the teacher moved out. The incident set a precedent, but one that wouldn't last for long in the fast-changing city.

During that time, black millworkers composed one-third of U.S. Steel's workforce. As the overall population continued to reach its peak, fueled by blacks who migrated there for work, it hit nearly 180,000 in 1960, an all-time high. The racial landscape of the city changed later that decade when Richard G. Hatcher became mayor in 1968. The successful attorney and outspoken city councilman was the first black mayor in Indiana and the first in any major city in the country. Real "black power" finally had a place at city hall, his supporters, from Gary's swelling black community to many white leaders in positions of power, cheered. Support also came from sympathetic leaders, liberals and well-wishers who watched on from across the nation.

After decades of feeling oppressed and discriminated through systemic prejudice and outright racism, the black community finally had its chosen one at the helm. Most had lost faith in white political leadership that only led to disappointment, heartache or anger. Hatcher, just thirty-four years old, boldly surfed the local wave of a national civil rights movement.

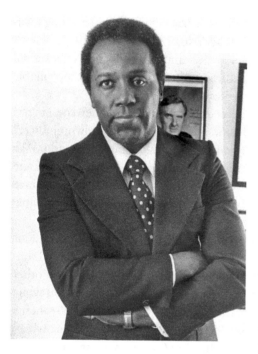

Mayor Richard G. Hatcher polarized an already polarized city. Supporters hailed him. Critics hated him and many still do, blaming him for their lost city even decades later. *Calumet Regional Archives.*

"Let us dare to make a new beginning," Hatcher proclaimed on January 1, 1968, in his inaugural address. "Let us shatter the walls of the ghetto for all time. Let us build a new city and a new man to inhabit it."

Since that day, Hatcher has been called a "liberator, destroyer, scapegoat and cipher of history," depending on the source, Lane writes. During Hatcher's first term in office, he often used the phrase "city on the move," to which his critics replied, "Yes, everyone's moving out!" The first waves of white flight began into the bordering town of Merrillville and continued south to other Northwest Indiana communities. Many businesses followed, most notably Sears and Roebuck, which also relocated to Merrillville. Public protests against the move didn't work, not even publicized threats of a boycott against the new store in a fancy new "super mall." Eventually, all the big-name department stores fled the city or closed for good, including Hudson's and Goldblatt's, a landmark fixture in the downtown area. The plunging trend became compounded as fewer businesses meant fewer customers, and fewer residents meant less of a reason to open a new business in the city. Despite Hatcher erecting the Genesis Convention Center in 1982 to revitalize the downtown business district, it didn't prevent the mass exodus from the city. Like so many downtown districts in the country at the time, Gary's business sector turned into a ghost town of blight and emptiness, another victim of suburbanization in America the Disposable.

For much of his five terms in office, Hatcher boycotted public events that were hosted in Merrillville and some other white-only suburbs out of principle. He often cited a legal-loophole bypass of the state's "buffer zone" law, designed to prohibit the incorporation of new towns within certain

miles of an existing city. It didn't stop Merrillville, a thirty-one-square-mile community, from becoming a town in 1971. Hatcher never forgot this legal loophole and its long-term ramifications for his city, despite being demonized by his critics and canonized by his supporters.

Most blacks praised him for saving their city from a future of white dominance and further oppression. Some called him a "black Moses." Most whites blamed him for ruining the city's once bright future while single-handedly causing their flight. Some called him a "black SOB." A thin line divided Hatcher's public image between pro-black and pro-poor versus anti-white and anti-business. Most scholars, however, fall somewhere in the middle regarding Hatcher's controversial run as mayor and lasting legacy.

"His legacy has been the subject of much debate, but when he left office in 1987 there was no denying that, to quote the historian Lance Trusty, 'the great Gary experiment' was over," Lane writes in his 2006 book.

Scholars suggest that the most damaging blow against Gary was its modern-day colonization—caused by white flight, much like African countries were colonized by the British.

"I wish more people understood this," said Samuel A. Love, an educator and community activist who lives in the Miller section of the city. "In colonialism, the oppressed come across as the oppressors and the oppressors come across as the oppressed."

Love cites several still-existing factors for his damning conclusion of colonization on the smokestack shoreline of Lake Michigan. "There is U.S. Steel, which treats the city as its dump while most of the mill's workforce lives beyond the city," he said. "There's the white regionalists—such as the Regional Development Authority and Northwestern Indiana Regional Planning Commission—who treat Gary's assets as their own. Yet they don't hire local workers and continually disrespect Gary's population by putting the wants of white, non-Gary residents above the needs of our citizens."

"There's the south county slumlords and other out-of-towners who are sitting on Gary properties, dangerously decrepit houses, empty lots and so on. There are local rulers who look like the people they rule over, but who do the deeds of people who look more like you and I. There's a lot of money to be made exploiting Gary and there are plenty of resources to exploit."

Love, who's white, also agrees with Hatcher's repeated claims that, as mayor, he was mistreated and demonized by local media outlets. "This also fits the colonialist pattern of social control," Love said.

Several sociological studies by other scholars have shown that Northwest Indiana is one of the most segregated areas in the country, Lane said. But

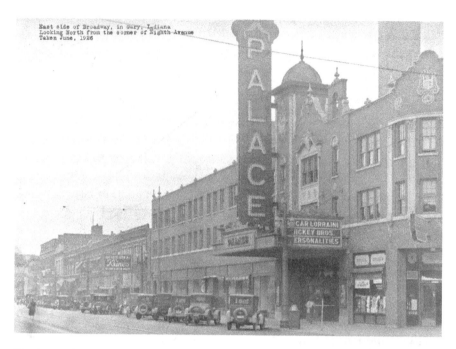

The intersection of Eighth Avenue and Broadway facing north in 1926. *Calumet Regional Archives.*

The intersection of Eighth Avenue and Broadway facing north in 2014. *Cindy Bean photography collection.*

whenever Hatcher cited this chronic problem, "I have been termed a racist," Hatcher noted in Lane's book.

Regardless of who is to blame and the politics behind them, racial undertones have played a critical role in the city's population implosion, which reaches a new low each new decade. In the 1980s alone, the population loss was nearly 25 percent, a higher percentage than any other U.S. city.

In 2015, almost 90 percent of city residents are black, a sharp change from a century ago, and the city's overall population is fewer than eighty thousand, even lower than U.S. census figures from 1930. This is the most visible loss in a once bustling city that has been emptied of so many lost resources.

OLD CHURCHES, NEW CONGREGATIONS

From the heart of a city radiates its life and influences. That is why our church was put where it is.
—Dr. William Grant Seaman, October 10, 1926, dedication of City Methodist Church

As Gary grew from a steel-framed town into a magic city, its sins began to demonize the hardscrabble downtown area. By the mid-1920s, Gary was already divided by race, class and ethnicity, even when it came to its dozens of churches, mostly in outlying areas. There were places of worship for the city's elite white population, who were primarily Presbyterians. There were churches for the city's rising ranks of foreign-born immigrant workers. And there were churches for its swelling black community. However, there were few churches that accepted all believers, allowing them to share their faith under the same roof.

One man in particular had a vision to change this—a grand vision with heavenly aspirations. Dr. William Grant Seaman, a native of Wakarusa, Indiana, came to Gary in 1916. He was known for his positive spirit, enthusiasm and friendliness. Seaman soon became an overseer of a small Methodist congregation with a downtrodden building, meager budget and hint of a salary. He craved more for his struggling parish. Seaman not only believed in the Lord but also believed he knew what Gary needed. He assembled other Methodist leaders in the community to share in his prophecy. He also implored Judge Ebert H. Gary to aid in the finance of

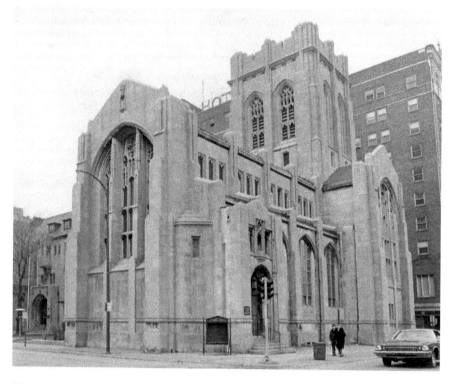

City Methodist Church, completed in 1926 at the corner of Sixth Avenue and Washington Street, boasted a gothic cathedral and was the largest Methodist church in the Midwest. *Calumet Regional Archives.*

an inner-city church, smack-dab in the soul of downtown Gary. Seaman's visionary proposal was accepted with plans to begin building something very special at 577 Washington Street. The church's new name: First Methodist Episcopal Church, also called City Church and then City Methodist.

Seaman sought other community leaders to get involved in his project of biblical proportion. In 1920, according to *Gary's First Hundred Years* by James B. Lane, he wrote a letter to one civic leader, Horace S. Norton, stating:

> *The downtown church is moving out to the suburban districts. Down in the city [are]…boarding houses, apartments, and tenements full of people. Down here are saloons and dance halls and brothels where God is forgotten. The church moves and makes its rest in the peaceful suburbs where this [is] needed, certainly, but not as deeply as in the thick of city's life.*

LOST PEOPLE AND COMMUNITIES

In other words, the faithful of downtown Gary needed God just as much as, if not more than, the surrounding communities. It took twenty-one months to construct the Gothic-style building out of Indiana limestone. Judge Gary advised U.S. Steel to donate $385,000 in matching funds, as well as personally donated a Skinner organ himself. Together, the church construction amassed to more than $1 million, equating to $15 million if built today.

On October 3, 1926, the dedication of City Methodist took place at Sixth Avenue and Washington Street. Seaman rightly anticipated that his stunning cathedral and adjoining recreational and fellowship center would attract a congregation in search of moral and spiritual commonality not only in a religious sense but also regarding education, athletics and social activities within the inner city. The adjoining center, called Seaman Hall, was connected to the massive nine-story church, and like its creator, it was ambitious while striving to serve the community in all things influenced by faith. The four-story Seaman Hall housed its own gymnasium, offices, kitchen, dining hall and education rooms. Its focal point was a top-notch stage with theater seating and an oak-paneled "fellowship room," complete with an elaborate fireplace. Seaman hoped to also build a rooftop garden and bowling alley, but neither materialized. The city's grandest structure of faith had its critics, many of them panning its monstrous size for a relatively small city. Others were more critical, calling it "Seaman's Folly." The potshots didn't deter the preacher.

City Methodist quickly lived up to its lofty expectations. By 1927, its 1,700-member congregation supported a staff of 6. Its curriculums were so popular that at one point, its music program was considered one of the best in the country. There were cooperative ventures with the Boy Scouts, the YMCA and the YWCA. Also, a Bible school program, in association with the public school corporation, served 5,000 students a year. Seaman's "folly" came to fruition, another dream realized in the Miracle City.

City Methodist appeared to run smoothly from the outside, but inner turmoil started to brew. Seaman had greatly miscalculated just how much money it would take to maintain such a massive structure and related programming. Popular educational programs became the first victims of a slashed budget. On a different front, Seaman hoped his new church would bring a new idealism regarding racism. He struggled against segregation throughout the city. Although full integration was not the idea for the church, Seaman cooperated with the black-based Trinity Methodist Episcopal Church. It wasn't enough. Racial tensions and segregation were too powerful for the majestic church to overcome. In 1929, many disgruntled church members asked for Seaman's removal. The once highly regarded faith leader was forced to leave the house

of worship he had built from the ground up. Simply put, he had worn out his welcome. As he left, resigned without acrimony, he penned a letter to his former members: "I love the city; I have had more fun here that I ever had before in my life." Tragically, Seaman was killed in an automobile accident in 1944. His ashes were interred in City Methodist's sanctuary. In a way, it's a blessing that Seaman didn't live long enough to witness what happened to his beloved church.

In the following years, City Methodist experienced its ebbs and flows, with different pastors and leaders at its helm. The Great Depression nearly drained its budget but not its faith. After World War II, the economy's revival from postwar steel production generated more workers to the city and also to City Methodist. Coupled with the population boom in the 1950s, its congregation reached up to three thousand members. The heyday lasted until the 1960s, when the church's congregation reflected the shrinking, embattled city. In the early 1970s, worshipers were becoming as old as the church itself. The once crowded refuge from sin became emptier for each service, its outdated pews holding fewer than three hundred people. The bills couldn't be paid. The pews couldn't be filled. The old church couldn't last for one more Sunday. City Methodist saved its last soul in October 1975.

Since then, the church's soul has been slowly dying. Long abandoned, its new congregation was composed of looters, squatters, rats and curiosity-seekers. In 1997, a massive downtown fire sealed its fate. The roof collapsed, the stairs turned to rubble and the stained-glass windows were just about gone. Almost all of its magnificent ornate detail has since been stolen, vandalized or ravaged by weather. Inside what's left of City Methodist is now hollow, empty and eerily quiet but not entirely gone. The sprawling property has become fodder for Hollywood movies, with seemingly fictional plans to make it into a ruins garden, modeled after similar ones in Europe.

In 2014, I had the opportunity to go inside the remnant walls of City Methodist before it was fenced off for public safety later in the year. I was escorted by urban-exploring photographers Larry and Cindy Bean, who live in south Lake County. For several years, dozens of "urb-ex" adventurers from across the country have made a pilgrimage to the old church. Here, they search for artistic beauty amid modern-day ruins. Here, they capture decades of destruction in the digital age. Inside the church, it's painfully quiet yet oddly peaceful. The holy cathedral has turned wholly disgraceful. It's besieged by fallen bricks, ripped up flooring, stripped walls and a vandalized altar. Inside Seaman Hall, I stood on the crumbling stage where so many local and nationally known acts once performed. I looked out to the fragments of balcony seats now filled only with dust, rubble and echoes of applause. The true folly of this historic church is

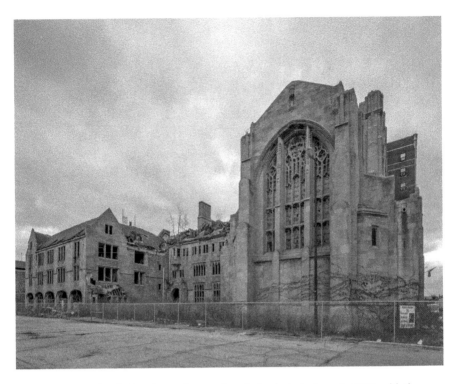

City Methodist Church, how it stands now after closing its holy doors in 1975, with the future possibility of becoming a "ruins gardens." *Cindy Bean photography collection.*

that it now serves as a microcosm for Gary in its past, its promise and its current condition. Inside the church sanctuary, I looked up through the damaged roof for a peek at heaven. There, I experienced an epiphany of sorts: City Methodist has been through hell and is lost forever. Its resurrection doesn't have a prayer.

Reborn Faith

Countless other churches in the city have suffered a similar fate as City Methodist. Research for this book has unearthed a long scroll of churches that have been razed, abandoned or used for other purposes since being built. Roughly two hundred places of worship still exist across the fifty-four-square-mile city. Most now house a different brand of faith than that for which they were originally built. The majority of these converted churches are Baptist, dating back to the earliest city residents in the First Subdivision. Regardless of denomination, each one remains a cornerstone of faith where souls are saved, believers are blessed

Miracle Faith Church on West Fifteenth Avenue symbolizes the state of many churches in a city haunted by demons from the past. *Cindy Bean photography collection.*

and generations of families return on a weekly basis. The churchly touchstones of ritual and tradition include the former St. Constantine and Helen Greek Orthodox Church at 510 West Thirteenth Avenue, which is the Koinonia Missionary Baptist Church. It's across from the St. Luke AME Zion Church. The First Presbyterian Church at Sixth Avenue and Madison Street, is now the River of Life Church. A sampling of other such churches include the former Dr. Martin Luther Slovak Evangelical Lutheran Church at 1165 Connecticut Street, which is now Zion Progressive Baptist Church, and Holy Family Church on east Ridge Road, which is now the Inspirational Church of the Harvest. Similarly, the Glen Park Baptist Church at Forty-second Avenue and Washington Street is now Christ Temple, and St. Michael Byzantine Catholic Church on Fifteenth Avenue and Madison Street is now Galilee Baptist Church.

This reflects a common theme in Gary regarding so many congregations that migrated into new churches, dating back several decades. For example, the members of St. Augustine Episcopal Church, in Gary's Tolleston neighborhood, relocated there after running out of space in the former Roman Catholic mission building in Midtown.

In the 1950s, church leaders recruited innovative Chicago architect Edward D. Dart to design their new house of worship. "A Yale graduate, Dart

studied with such modern masters as Eero Saarinen, Louis Kahn and Marcel Breuer," according to Indiana Landmarks. "Already known for his residential architecture, Dart was just starting to experiment with church designs."

"This was the first 'home of their own' for the African-American congregation, who were not welcome in the established Episcopal church in Gary. Segregation required separate prayer in addition to everything else. The congregation that boldly commissioned the modernist Dart included teachers, librarians, social workers and others," according to Indiana Landmarks. "Built in 1958, St. Augustine's was Dart's second church design, and the only one he designed for an African-American congregation. The building captures many of the hallmarks of his later church architecture—an unconventional roofline, hidden lighting, open space, and minimal windows in favor of allowing the natural materials to create a serene place of worship."

St. Augustine's, which earned a spot in the National Register, is the exception to the rule in a city where churches have been gone or deserted long ago. A partial list includes St. Nicholas American Carpatho-Russian Church at 1385 Johnson Street, the original Full Gospel Tabernacle Church at 800 Connecticut Street, Methodist Episcopal Church at 700 Adams Street and Temple Beth-El at Connecticut Street. These churches and others served every ethnic group in the city during its early days, from Croatian, Russian and Swedish to Polish, Lithuanian and Jewish believers.

Several Catholic churches have been lost for essentially the same reason as the others—lack of believers, not lack of belief. They include Blessed Sacrament, St. Emeric, St. Luke, Holy Trinity, Sacred Heart, St. Anthony and St. Casimir, according to Catholic Diocese of Gary records. One more Catholic church under the diocese's protective umbrella is rumored to be closing next. St. Mary of the Lake, in the Miller section of Gary, once brimmed with members. In 2014, not so much.

St. Mary was established in 1929 by Bishop John F. Noll, the bishop of the Fort Wayne Diocese at the time. The parish's first Mass was July 1 of that year, and the parish's first church was dedicated on land donated by the Ansbro family in 1931. Mother Nature and Father Time, however, conspired to destroy the original church. On July 16, 1956, its convent was struck by lightning. On November 15 of that same year, a fire destroyed the church. It had to be rebuilt, and it was, around a spectacular Casavant pipe organ that still towers over the pews from the rear balcony. In 1961, the Gary Diocese's first bishop, Bishop Andrew G. Grutka, laid the cornerstone for the new church. Soon after, its faithful congregation swelled and then gradually shrunk, reflecting the city's population.

St. Nicholas American Carpatho-Russian Church, located at 1385 Johnson Street, opened in 1935 and is now boarded up for good. *Author's collection.*

In 2014, fewer than one hundred families regularly attended Sunday services despite a capacity for ten times that amount, according to the Reverend Selvaraj Selladurai. "We are not a parish that is growing, but we have a very faithful and loyal parish." This can be said for many churches in the city, which share a chronic problem: a graying, dying congregation whose average age is seventy-five. On St. Mary's entranceway wall, an ancient message rooted in scripture greets the flock: "I am the vine…you are the branches." Too many branches here are old, brittle and falling off the tree.

Still, Gary's oldest surviving church, St. John Lutheran, stands strong in the Tolleston section of the city, founded by German settlers in 1868. Designed by the Julius Kaaz Manufacturing Company, it gives hope to city leaders that churches remain the foundation of Gary—and its rebirth. Before his death in 2013, former Gary mayor Rudy Clay insisted that despite the city's struggles, "the glory of Gary" will be reborn through its many churches. The city has more churches than any other similarly sized city in the country, according to Clay, a 1953 Roosevelt High School graduate. "It's true, you can look it up," he said proudly.

BUSINESS DISTRICT: FROM BROADWAY TO BUST

UNION STATION RUINS AND OTHER CIVIC LOSSES

We lift a song in praise of thee; Garyland, my Garyland, we know what a great spot you'll be, My Garyland, Garyland. The wheels of progress all will hum; and Gary will be going through all the splendid years to come, my Garyland, my Garyland.
—The song "Garyland," 1908

The building looks like a target from repeated military air strikes in post-apocalyptic warfare. So much so that the site has been used for several Hollywood movies, as if it's in a third-world country or a combat-ravaged planet after World War III.

The once elegant Union Station, however, has been attacked by decades of neglect, weather-related assaults and bombed-out promises for its salvation. The 115-year-old station is located at 301 Broadway, near an entrance to U.S. Steel. The structure's roof is missing in spots, its walls are littered with graffiti and its original marble flooring is trashed with rubble, wiring and garbage. It is a harsh reminder of what used to be in this transportation hub of a major city. The two-story station sits between two elevated rail lines, the Baltimore and Ohio and Lake Shore and Michigan Southern lines.

Inside, it's as quiet as a morgue. Outside, loud trains rumble past, just as they did a century ago. However, none stop here any longer. They pass it by, just as a half century of time has done since the station expired.

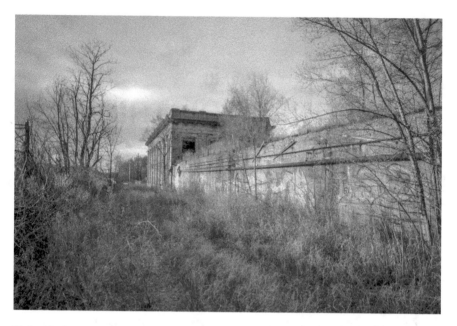

Union Station was placed by Indiana Landmarks on the Ten Most Endangered Places in Indiana list. *Cindy Bean photography collection.*

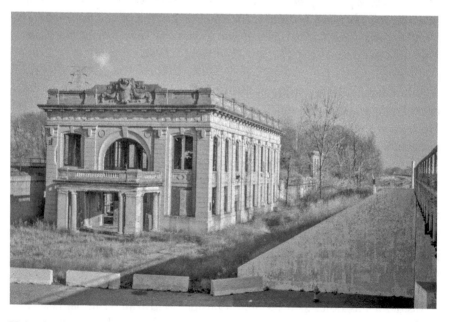

Union Station in its current state at Second Avenue and Broadway, near the entrance of U.S. Steel. *Cindy Bean photography collection.*

Written above an outdoor balcony, the station's ornate trim now serves as its headstone epitaph: GARY.

The station, built in 1910, features a Neoclassical Beaux-Arts style of architecture, once in vogue utilizing the latest in twentieth-century steel-reinforced poured concrete, according to the National Railway Historical Society. Designed by architect M.A. Lang, it boasted a massive skylight, sunken-paneled ceiling and hanging chandelier.

In its heyday, it housed thousands of travelers, passengers and commuters. Facing west, toward Broadway, it served multiple purposes for the city's residents. Its main hall was spacious, with an elegant staircase leading upstairs to the loading platforms. A tunnel walkway to the north leads to a staircase to another boarding platform on the opposite side of the railroad tracks. These days, it's overrun with weeds, debris and danger. After closing more than a half century ago, the easy-to-miss station is only a memory of its former glory.

"It was an amazing train station to visit, whether you were catching a train there or not," said Gloria Hanratty of Gary, who often shadowed her grandmother at Union Station. "She would catch trains there to visit our

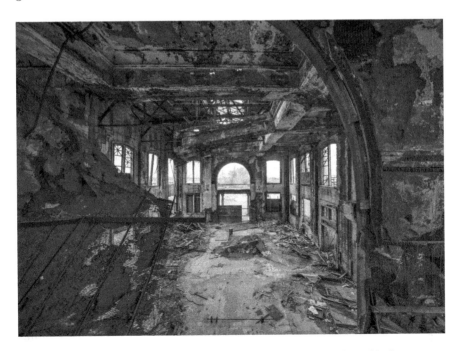

Union Station once offered sophisticated interior styling, complete with marble floors, chandeliers and arched entranceways. *Cindy Bean photography collection.*

family in other cities. I remember it being packed with people, everyone going different directions all at once. It was all very exciting."

My mother also visited Union Station as a young girl while waiting for her grandfather to pick her up for a ride to his home in Michigan City. He was a conductor on the South Shore train, and he would pick up his grandkids at the station on his return trip from Chicago.

Residual excitement has ebbed and flowed through the years with talk of preservation efforts to resuscitate the old structure. Once listed as one of the ten most endangered landmarks in the state, it later had to be removed—no money, no interest, no hope.

Redevelopment ideas also emerged, such as turning it into a museum, but those ideas gathered dust and blew away. Its west-facing façade is now boarded with plywood, though its entrance remains open to curious visitors and urban explorer photographers.

Hundreds of thousands of motorists pass it each year along the Indiana Toll Road, as do train commuters on the South Shore rail line, though they probably never notice it. And why should they?

Gary Public Schools Memorial Auditorium

The Gary Public Schools Memorial Auditorium is another historic landmark that is lost yet still visible—painfully so—at Seventh Avenue and Massachusetts Street. Built in 1927 and inspired by schools superintendent William A. Wirt, the massive civic building was made from brick, terra cotta and limestone. It many ways, it housed the soul of the city for generations. It hosted every event imaginable, from boxing fights and regional basketball tournaments to high school graduations, union rallies and musical acts. Even the Jackson 5 won a talent contest here in the band's early days before leaving Gary.

The stately structure housed more than five thousand guests, which came in handy when celebrity crooner Frank Sinatra performed there in 1945 amid racial tensions at a Gary school. Every seat was taken, and many of the students were taken aback with Sinatra's pro-integration pep talk during his performance. He called the strike "the most shameful incident in the history of American education" and then sang "The House I Live In" and "Old Man River." His criticism didn't stop the striking students, who were fueled by their parents' prejudices, but it did direct the national spotlight to Gary's schools and, for a moment, the Memorial Auditorium. Its majestic exterior walls were designed in ornamental brickwork and

BUSINESS DISTRICT: FROM BROADWAY TO BUST

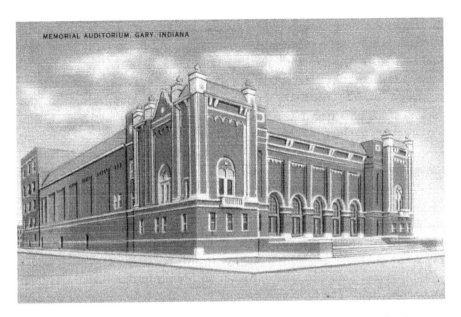

The Gary Public Schools Memorial Auditorium, built in 1927 from inspiration by William A. Wirt, hosted concerts, sporting events and high school fanfare. *Christopher Meyers collection.*

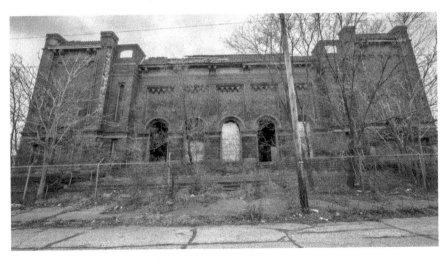

The Memorial Auditorium was adorned with inscriptions describing different types of endeavors to be housed inside, including art, music and athletics. *Cindy Bean photography collection.*

adorned with harp motifs. Expertly chiseled inscriptions hinted at the activities hosted inside, such as ART, MUSIC AND ATHLETICS. "Politics" also could have been inscribed there.

On October 25, 1948, President Harry Truman gave a resounding campaign speech, warming up his Democratic supporters with this humorous gem: "I heard a story not long ago about an elderly man who was driving into Gary, and he gave a lift to a young fellow who was going his way," Truman told the audience. "During their talk, the older man asked the young fellow, 'What takes you to Gary?' The young man kind of hesitated, put his head down, and finally said: 'I am working for the Republican State Committee. They are sending me to Gary to see what I can do to get the people there to vote the Republican ticket.' The old man was silent for a while, and then he said: 'Son, I've listened to a lot of sad stories for the last fifty years, but that's the saddest one I've heard yet.'"

At that point in time, the sad story of the Memorial Auditorium had not yet been written. The building slowly fell into disrepair, though it was still utilized into the 1970s. On October 12, 1997, the Great Gary Fire raged along Broadway and surrounding blocks, consuming several buildings, including the auditorium. News accounts state that the auditorium's

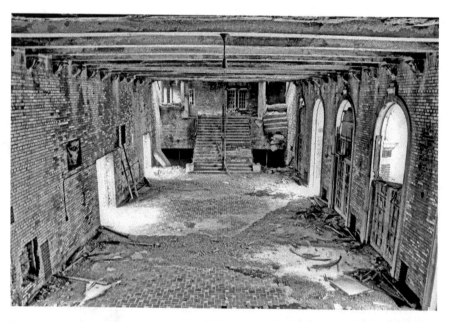

The Memorial Auditorium was in operation until the 1970s and gutted by fire in 1997. *Cindy Bean photography collection.*

foundation cornerstone was laid exactly seventy years earlier to the day. Coincidence? Yes, but the fire only accelerated the inevitable—the old building was finally laid to rest. Only its façade survived the blaze and still stands, open to anyone who walks past. Plans to make it into a war memorial never materialized, of course. A chain link fence, breached many years ago, does little to keep out gapers, vandals and photographers. It is just another structure in the urban ruins of Gary. Originally erected to honor the war dead of World War I, the auditorium is now a fatal casualty of a lost war.

Gary Public Library

Over the past few decades, every type of structure in the city has been lost to disaster, neglect or abandonment. However, it's the structures that are still visible, such as the Memorial Auditorium and Union Station, that taunt each city administration and haunt nostalgic Gary natives. This also holds true for the Gary Public Library's main branch at 220 West Fifth Avenue, which closed in 2012 due to financial problems. Since then, it's been another civic building gone but still there, with promises of reopening as a cultural center. The library system's first chapters tell a different tale of its storybook promise and fairy-tale potential.

The Gary Public Library was first organized on March 30, 1908, founded by Ora L. Wildermuth, whose name graced one of its branches. The first library director, Louis Bailey, worked out of a rented storeroom at 33 West Seventh Avenue later that year. The first library consisted of 936 volumes and 75 magazines when it opened that December, according to Gary Public Library archives. In 1911, it was moved to 620 Washington Street, but just temporarily. Andrew Carnegie, the former steel magnate turned public library philanthropist, offered a grant of $65,000 for the construction of a new building. Built on the northwest corner of Adams Street and Fifth Avenue, the library opened on November 17, 1912. It was built in the Classical Revival style, constructed out of Bedford stone.

In 1945, the library became too overcrowded and too limiting for daily functions. A decade later, a consulting firm recommended a new library be built, but financing became an obstacle. "The library decided to finance the new building by selling bonds," the Gary Public Library archives state. "The problem with this was that, while the 1947 Library Law allowed libraries to sell bonds, the law had yet to be tested in the

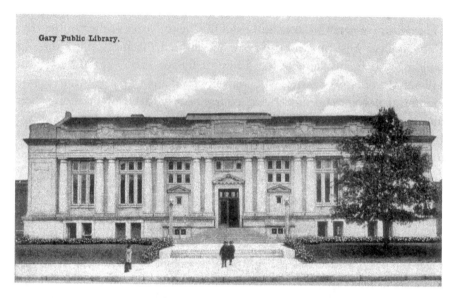

Gary Public Library.

Gary Public Library, first built in 1915, was financed with a $65,000 donation from Andrew Carnegie and demolished in 1962 for a new building on the same site. *Christopher Meyers collection.*

courts. And until the law was proved to be constitutional, the bonding companies would not issue any bonds."

This is when the Friends of the Gary Public Library got involved and tested the constitutionality of the law with a "friendly" lawsuit. It went all the way to the Indiana State Supreme Court, which ruled in 1960 that libraries could sell bonds for construction projects. The old Carnegie library, then in its fiftieth year of service, was razed, and a new one was constructed at the same location, on the same land once donated by the Gary Land Company. Constructed of Indiana limestone and featuring an auditorium, conference rooms, two floors for shelving and a full basement, it cost $2.2 million and opened on May 4, 1964. Fifty-one years later, the now-dated main library struggles to write a new chapter amid chronic financial problems.

Unfortunately, Carnegie and other civic-minded philanthropists are fictional characters this time around.

Civic Structures in Ruins

Built in 1915, the city's first fully designated U.S. Post Office was located at 125 West Fifth Avenue, next to the YMCA building at the time. It was another

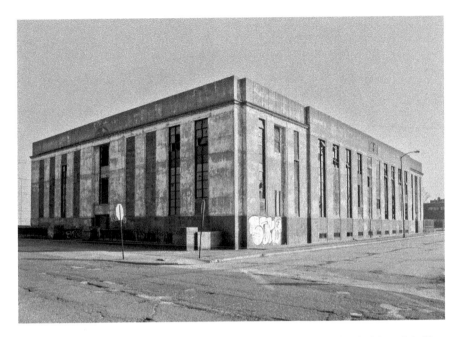

The U.S. Post Office, opened in 1936, still serves as a microcosm for the city's lost civic life, abandoned many years ago. *Cindy Bean photography collection.*

sturdy structure designed in Neoclassical style with an arched entranceway flanked by Greek columns. Before its completion, all post office business was conducted in the Gary Land Company building, the first permanent structure in the young town. By 1936, a new Art Deco building was built under the government's New Deal–era Works Progress Administration, at 109 East Sixth Avenue. Designed by architect Howard Lovewell Cheney, it also housed other federal agencies and military offices. By the 1970s, the city's main post office was relocated to its current site on Martin Luther King Drive, near Fifteenth Avenue. The original building on Fifth Avenue was converted into the Croatian Catholic Union USA headquarters. It is long gone, and its successor is empty and abandoned, another empty hulk in a city of countless civic losses.

The Masonic Temple, located at Sixth Avenue and Jefferson Street, was dedicated on May 1, 1926. The stately building served the Free Masons organization for many years before the lodge relocated to Merrillville. The original building is only a memory for its members and their families. Similarly, the Elks Lodge Temple at Sixth Avenue and Washington Street was later converted into the H. Gordon and Son department store, a

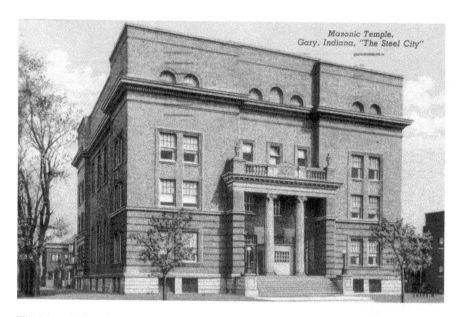

The Masonic Temple, dedicated in 1926 at the intersection of Sixth Avenue and Jefferson Street. *Christopher Meyers collection.*

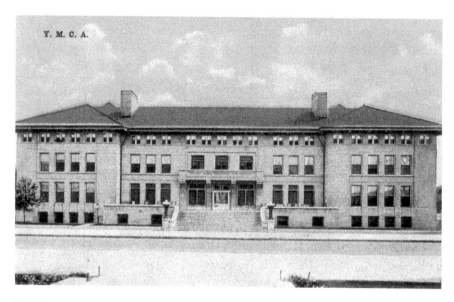

The Gary YMCA was dedicated in 1912, using a $400,000 donation by Judge Gary and U.S. Steel, and was demolished in 1964. *Christopher Meyers collection.*

longtime retail fixture in the city. A fire later gutted the building, which is now in ruins. A similar fate awaits the Gary Heat, Light and Water Company at 900 Madison Street. It's still there but still lost to any productive civic functions.

The original YMCA building, also dedicated in 1912 on land donated by the Gary Land Company, was a landmark attraction for more than a half century. The four-story edifice boasted Indiana limestone, marble columns, elegant staircases and other sophisticated amenities to ensure it lasted 100 years, as with many of the early constructions in the city. The grand building was demolished in 1964 for a more contemporary YMCA.

The Genesis Convention Center, the signature downtown landmark of former Gary mayor Richard G. Hatcher, is not lost. But…but…yes, the enormous arena is still in operation between Fourth and Fifth avenues near Broadway. It holds eight thousand guests, though it's been years since that many people packed the arena. Yes, it has hosted innumerable events since its completion in 1981, with an adjacent hall for plays, banquets and concerts, in addition to updated renovations twenty years after its creation. And yes, it

The Genesis Convention Center is not lost but has failed to serve as the economic redevelopment tool first imagined in 1981. *Author's collection.*

once housed the Gary Steelheads basketball team, the Gary Splash and the Gary Dawgs. Plus, the Miss USA Pageant in 2001 and 2002. However, the arena's original hope and promise is lost, failing as a major redevelopment tool as initially planned. It ultimately didn't attract new businesses to the downtown area or as many tourism dollars and outsiders as expected. Instead of becoming the centerpiece for the city's economic comeback in the 1980s, it has turned into a glaring example of another broken dream in the city of the century.

FROM HOLIDAY INN TO SHERATON TO TOTAL VACANCY

It's ugly, it dissuades potential investors, and I think the removal shows great progress for the city.
—*Joseph Van Dyke, redevelopment director, city of Gary, regarding demolition of the Sheraton Hotel*

In many ways, the former Sheraton Hotel in downtown Gary best symbolizes the city's rise, fall and, ultimately, its demolished dreams. The towering fourteen-story, three-hundred-room hotel opened as a promising Holiday Inn in 1968, part of a national wave of hotel openings. It was later designed as the tallest piece in a grand revitalization project to attract out-of-town tourists and new businesses into the struggling downtown area.

The Holiday Inn was erected on the site of the old Broadway Hotel, which was built after the turn of the twentieth century. It burned down in the early 1950s. The new inn offered all the amenities that a big city needed, including a bar, parking garage and restaurant. City officials heralded it as the boon that Gary needed to bounce back from steady decline and urban blight. However, the hotel's promise checked out early, and the property closed just four years later.

In hindsight, obvious reasons posed insurmountable challenges, such as a poor location with lost traffic flow, hotel rates too costly for residents and the city's infamous reputation warding off potential guests. Even after closing off the hotel's top several floors to save money, it couldn't sustain the lack of business.

Former Gary mayor Richard Hatcher helped resurrect the failed hotel by using it as a cornerstone for his renewed redevelopment efforts, bolstered by federal funding. The city poured millions of dollars into the property,

BUSINESS DISTRICT: FROM BROADWAY TO BUST

An architect's rendering of the Holiday Inn in 1968, located at Fourth Place and Broadway. It closed four years later. *Calumet Regional Archives.*

with trendy upgrades and new promises. "ALL NEW AND NEARBY," stated its first brochure in 1978. "The Best Place for a Taste of the 80s—Today." Guest room rates ranged from twenty-seven to eighty dollars, with on-site attractions, including the Visions Lounge, Gazebo Restaurant and twenty-four-hour valet parking. Its new name: the Sheraton Hotel. Hope once again took the elevator to the top floor of expectations.

The Sheraton featured a planned skywalk bridging across Broadway to the proposed Genesis Convention Center. But the skywalk never fully reached the downsized center, hinting at the hotel's future lack of reach in the business world. In time, this newest incarnation of the hotel also failed to attract the revenue needed to sustain itself, let alone attract other related dollars to the city. Hatcher used city funds to keep it afloat for a couple years; however, the flashy new hotel slowly closed, one floor at a time, one failure at a time. It officially shut its doors in 1985 after being damaged in a fire, accelerating the inevitable.

Since then, numerous people, groups and city leaders pledged to reform the building for various purposes. When casino boats barged into Gary via Buffington Harbor on Lake Michigan, talk of reopening the property was promised by hotel industry mogul Donald Trump. It never happened. A

$10 million promise by Trump also never happened. Instead, the city won a consolation prize to twice host the Miss USA Pageant. Other city officials talked about converting the dilapidated hotel into a housing complex or mixed-use commercial space or leased office space for meetings and conferences. Those ideas never materialized either.

Former mayor Rudy Clay boasted hopes of turning the hotel into a needed high-rise housing project for low-income seniors. The much-ballyhooed proposal also highlighted commercial space, a medical center satellite office and brand-name coffeehouse on the lower floors. An investment organization called the New Gary Development Group emerged on the scene, hung its banner on the hotel and painted new hope across an old disappointment. The banner stated, "Creating a New Gary," which later came down amid new disappointments. Funding problems returned. Politics did, too. Making matters worse, asbestos was found inside the hotel, scaring off future plans. It spread like a cancer in the sickly fourteen-floor structure, diagnosed on different floors by various environmental agencies. In the meantime, the hulking building became littered with graffiti, vandals and squatters. Travelers along the nearby Indiana Toll Road couldn't help but notice the towering eyesore. Cosmetic attempts to drape its exterior with fresh paint, a massive banner and colorful facades failed to hide its age spots. The building died a slow death with no hope for plausible renovation. The entire property became a liability to the city, towering over city hall for nearly twenty years like an ominous albatross. Each incoming mayor couldn't avoid looking at it each day, and each mayor couldn't convert it or raze it—that is, until 2014, when the Sheraton Hotel was finally and completely demolished. Mayor Karen Freeman-Wilson heralded the long-awaited accomplishment as a major feat. It was, for a city struggling to rid itself of its past.

The hotel site is empty, a lost landmark that tops the list of vanished or failed businesses in Gary, from mom-and-pop joints and retail chains to corporate companies and other long-gone hotels, such as the city's other Holiday Inn on historic US 12/20, built in the 1950s near the Aetna section of Gary. It sported the same standard amenities of so many Holiday Inns—lounge, outdoor pool, restaurant—that were constructed across the country during that era. Thousands of motorists stayed there after hopping off the east–west "Dunes Highway" or the new Indiana 65 from the south. Nevertheless, this Holiday Inn couldn't withstand the city's downfall either, and it closed down. Other hotel and motel names, such as the Interstate Motor Inn, hoisted their roadside signs on the property, but none stayed very long. This site is a shadow of its former glory, though not completely

In many ways, the former Sheraton Hotel in downtown Gary best symbolizes the city's rise, fall and, ultimately, demolished dreams. *Cindy Bean photography collection.*

The rooftop swimming pool at the former Sheraton Hotel aptly showed its neglect through the years before being razed in 2014. *Cindy Bean photography collection.*

Hotel Gary, constructed in 1927 at a cost of $2.5 million, boasted four hundred rooms and housed out-of-town celebrities, including Frank Sinatra. *Calumet Regional Archives.*

razed like its sister hotel in the downtown area. Only a honeycomb shell of the building exists, allowing twenty-first-century motorists a peek, literally, through its nostalgic past.

Other hotels across the city from previous eras have been lost for similar reasons or to disaster. For example, the Broadway Hotel was destroyed by fire. Too many historic hotels to count have been destroyed by the steady blaze of time, including the Fitzgerald Hotel (reportedly the city's first hotel), the Gary Hotel, the Hotel Victoria, the Olympic, the Baltimore, the Gotham and the Tolleston Hotel, which predated Gary.

Hundreds of stores, businesses, restaurants and roadside attractions have been lost through the decades. Some were landmarks, others were not. None of them have been forgotten by Gary natives, who are quick to remember not only their location but also the fond location in their heart. Harvey's dime store, Dickerson's drugstore, the Copper Kettle, Art's Bakery, the Old Mill, Kresge's, Galler's flower shop, the Tivoli Theater, Clover Leaf Dairy, Tolleston's Dairy Maid, Pete and Snooks, the Glen Park Bakery, Jackson's

Hotel Gary still stands but under a new persona as Genesis Towers, a senior-housing facility. *Cindy Bean photography collection.*

Restaurant, the Beauty Spot restaurant on Broadway and Ridge Road and the Dog-n-Suds root beer stand on Georgia Street, to name just a few. Bigger names such as Sears and Roebuck, Goldblatt's and Gordon's department stores attracted hundreds of thousands of customers. Many of them still remember strolling through the aromatic candy and nuts department in Sears, hustling through the revolving doors at Goldblatt's for its famous cookies or wearing white gloves in the tea room at Gordon's.

In the Miller section of Gary, former city residents reminisce about the A&W root beer stand, the Lure hamburger stand, Jack Sprat ice cream shop, Ben Franklin dime store, Wilco grocery store, the Dunes Drive-In Theater, Sammie's Drive-In and the 12/20 Bowling Alley, among others. As legend goes, the Dunes Bowl featured forty-three lanes, an unconventional twist. Most bowling centers have an even number of lanes to accommodate leagues. The Dunes, however, sported an odd number so it could advertise that "open bowling" was always available. At least one lane, anyway.

So many other businesses have been lost in the shadow of the Sheraton Hotel's demise: soda fountains, car dealerships, coffee shops, bakeries, drugstores, skating rinks, gas stations, grocery stores, insurance agencies, medical offices, you name it. Even the city's major newspaper,

the *Post-Tribune* (formerly the *Gary Post-Tribune*), relocated to another town, following so many businesses. All of these painfully familiar names are now gone, lost forever. Only their memories have endured, to be treasured for generations.

Broadway: Downtown's Façade of the Past

Cancel all engagements! Don't let anything keep you from the inaugural ceremonies of the wonderland. As a Garyite you will be proud of the newest of Gary's possessions.
—*Advertisement, Palace Theater, 1920s*

Chuck Hughes vividly remembers when Gary was the entertainment mecca of Northwest Indiana and beyond. Concerts, movies, plays, live music performances, sporting events—the city had it all when he was growing up. "There was always something to do," he said.

Hughes was born and raised in the Tolleston area during the city's heyday. After graduating from college, he returned to Gary to be a city firefighter for thirty-four years. He also served for sixteen years on the Gary Common Council, and in 2007, he ran for mayor, unsuccessfully. Hughes knows the city. He knows what it was in its glory days. He knows what it is today and all that entails. "It's tough getting people to come into this city," said Hughes, who now serves as executive director of the Gary Chamber of Commerce. "I'm doing everything I can to bring back entertainment into this city. And bring back the lost crowds."

Thousands of people commute into the city each day for their job or work-related responsibilities, including steelworkers driving into U.S. Steel around the clock. The same can't be said for recreational entertainment or sporting events, beyond the city's minor-league baseball team, the Gary SouthShore RailCats. "That's the same old problem we always run into here," Hughes said with a shrug.

Hughes, who played basketball in college, is the mastermind behind the Lakeshore Classic basketball-related event. It's a family-oriented affair, focusing its activities on raising educational awareness and academic achievement through the game of high school basketball. The event offers a needed boost to the city's "image enhancement," Hughes said, featuring previous guest speakers like former college coach Gene Keady, NBA coach Gregg Popovich and former Chicago Bulls player Bob Love.

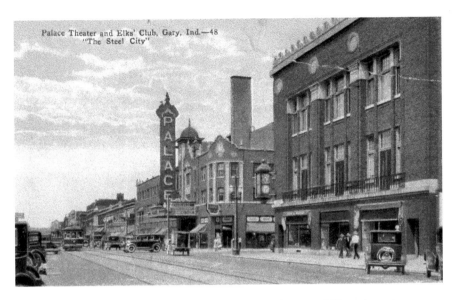

The Palace Theater, built in 1925, offered three thousand seats and film-going enjoyment for generations of city residents. *Christopher Meyers collection.*

Its seventh year, 2014, again showcased several high school basketball teams from the region and Chicago area. "Basketball is the hook to bring people into this community," said Hughes, whose office is located at 839 Broadway, inside the former Sears, Roebuck and Company store. "We want this to be a destination event, so people can come into Gary and have a good time."

This was commonplace in the 1950s and '60s, during Gary's peak as a destination city not only in Indiana but in the Midwest. One of its biggest attractions was the Palace Theater, which lived up to its name at 791 Broadway. The opulent 2,500-seat venue opened its doors in 1925 in grand fashion, adorned with Greek and Roman statues, lavish marble décor and chandeliers imported from Spain. Themed as a Spanish castle, the fingerprints of theater architect John Eberson and builder Ingwald Moe could be found in every corner. Nationally known performers graced its stage, with vaudeville acts and elaborate musicals entertaining thousands of guests. Its larger-than-life screen captivated generations of moviegoers who watched cartoons, newsreel footage, double features and films of the day.

All of that came to an end in 1972, when the Palace closed. Attempts for an encore reopening turned out to be, appropriately, just for show. The building still stands, but it's in ruins, easily accessible to gapers, vandals and the homeless. Inside the rubble, the dangling skeleton of a chandelier hangs like a body from a noose. Windows are broken. Tiles are shattered. The

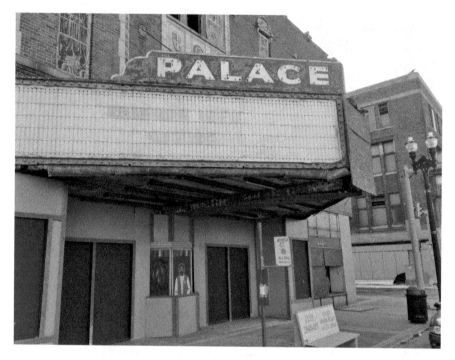

The once elegant, long-abandoned Palace Theater on Broadway sells only a façade of its former glory. *Author's collection.*

theater's overhead marquee is empty and rusted. At its sidewalk entranceway, a vanishing façade of an old-fashioned box office is painted on boarded-up windows. After Michael Jackson's death in 2009, a sign stating "Jackson Five Forever" hung from the marquee. Like so many audiences that once packed the Palace for nearly a half century, it's also long gone. Similar painted façades of fake storefronts can still be found along Broadway, many of them erected when the city hosted the Miss USA Pageant in 2001 and 2002.

It's a far cry from Gary's earlier days when Broadway bustled with shoppers, diners and visitors to be entertained. Through the decades, Gary boasted dozens of movie theaters alone. The city's first theater was the Broadway Theater, offering audiences "moving picture" comedies and live entertainment. Its success prompted others to open across the city, including the Derby, the Lyric, the Gem and the Princess. Incidentally, these early theaters used film with highly flammable components, causing fires to close the venues. Many came and went, with a few exceptions, such as the Gary Theater. Originally called the Gary Opera House, it was known as the most attractive theater in Indiana in its time. The site boasted big-name

The Gary Theater, opened in 1915, hosted audiences until 1951 while attracting top-notch entertainers from across the country. *Calumet Regional Archives.*

entertainment from major cities such as Chicago, Boston and New York. Famous actors played there, from Sarah Bernhardt to the Marx brothers. With more elegant theaters such as the Palace, the Tivoli and the Indiana Theater luring patrons away from the Gary Theater, the theater took somewhat drastic measures to attract business. It reportedly played more "adult" entertainment, including exotic dancers and burlesque shows. Amid growing criticism and police involvement, the theater returned to more family entertainment.

Former Gary resident Susan Gilyan recalled watching movie matinees at the fabled Glen Theater on Ridge Road, just west of Broadway. "When it opened, it played Disney movies," she noted. In 1968, the theater's opening attraction was Disney's *The Happiest Millionaire*, followed by several first-run Disney films throughout the 1970s, such as *Sword in the Stone, The Apple Dumpling Gang, Herbie Rides Again* and *One of Our Dinosaurs Is Missing.* The theater also played action movies and comedies before experimenting with X-rated films, according to the theater's website. The venue closed in 1981, another victim of crime and vandalism in the city. In 1983, it reopened again featuring Christian-themed films but

couldn't find an audience. Despite a marquee sign promising "Reopening Soon," it remained vacant. Its latest incarnation houses theatrical art performances and educational opportunities, according to its website and electronic marquee.

Back in the 1950s, near the Palace Theater, Gary native Ed Wroblewski bumped into the girl who would someday become his wife. Their storybook encounter ended like a Hollywood movie. Here's how it began: a year earlier, Wroblewski and a pal attended dances at the Gary YWCA. The venue was a popular place for teen dances and other social events. One night, he saw "the dream of his life" dancing on the floor. The music started, and Wroblewski asked her to dance. To break the awkward silence, he quipped, "You know what—I'm going to marry you."

The music ended, the dancing stopped and the two dancers parted ways. Ed felt so embarrassed for sticking his foot in his mouth. But time goes on, and wounded feelings heal. When he saw the girl again walking down Broadway, near the Palace, he caught up with her to chat on a beautiful sunny day. The two hit it off, they began dating and he eventually took her to her senior prom at Lew Wallace High School.

"I was truly in love with her," Wroblewski noted later in his entry of the South Shore Convention and Visitors Authority's "Engagement Stories along the South Shore Contest." The couple dated for a couple of years before he finally popped the question. She said yes. He gave her the engagement ring in a cemetery close to her home, and their parents hosted a small party for the occasion. Ed was called for active duty in the U.S. Naval Reserves so they decided to get married a month before he left for training. Time goes on, and a year later, while stationed on a ship north of the thirty-eighth parallel in Korea, he heard bombing in the distance.

"I was scared and had tears in my eyes because this was my first wedding anniversary and I was going into battle," Wroblewski said while thinking of his newlywed wife, Alma.

His ship entered a harbor for battle, and all guns were blasting away, with enemy gunfire coming from all directions. Angry at being at war instead of in his sweetheart's arms, he went down below and asked a gunnery officer if he could give the enemy "a wedding anniversary gift." The officer agreed, and Wroblewski took control of the instrument panel. He pulled the triggers and yelled, "That's for making me miss my first anniversary!" Then he smiled, thanked the officer and went back to his battle station.

Again, time goes on, and the couple later celebrated their sixtieth wedding anniversary.

"Not too bad for a guy who stuck his foot in his mouth many lovely years ago," he wrote. Another love story in the city, thanks to a chance encounter on Broadway.

A PRESERVATIONIST'S HEARTACHE

From a historical preservation perspective, too much has been lost in the city of Gary over the past few decades. Too many homes, buildings, businesses and other significant structures are gone forever, too far gone for preservation efforts. But others are on the verge of oblivion, soon to be demolished if not preserved by caring or concerned residents and outsiders.

Indiana Landmarks is a nonprofit organization that fights to defend architecturally unique, historically significant and communally cherished properties. The organization rescues such properties, rehabilitates them and gives them new purpose—"saving our state's shared heritage and bringing new life to communities," the group states.

Formed in 1960, Indiana Landmarks ranks as the largest private statewide preservation group in the United States, with an Indianapolis headquarters and eight regional offices, including one in Gary. A handful of lost or endangered sites in this city have caught the attention of Tiffany Tolbert, director of Indiana Landmarks' northwest field office in Gary.

Several years ago, Tolbert moved here from Atlanta, and because of this, she offers a uniquely qualified perspective without the nostalgic bonds of hometown reminiscences. "I do not have any memories of these sites in their heyday, but after learning their history, I have gained an appreciation for their historic and architectural significance," she said.

Historic preservation, supporters agree, is more about the future than the past. It's about enhancing a community's quality of life and making it attractive and meaningful to future generations. The following is Tolbert's short list of the most unforgettable buildings or districts that have been lost to time, weather, abandonment or other compounding factors. The list includes properties that are still salvageable and awaiting rescue efforts. But the organization can't do it alone. It needs local support, including from city officials, concerned residents, nostalgic natives and individuals, like Tolbert, who have simply fallen in love with the city.

St. John's Hospital

St. John's Hospital still stands, but barely, on the corner of Twenty-second Avenue and Massachusetts Street in the Midtown section of the city. Designed, built and staffed exclusively by blacks, the facility served a crucial role at a time when blacks were not admitted to other hospitals. "It was the only hospital built for African Americans in Gary," Tolbert said. The hospital was designed by William Wilson Cooke, recognized as Indiana's first registered black architect. He also is credited with designing the First AME Church, the Stewart Settlement House, the Campbell Friendship House and numerous other buildings in the city. He became a resident of Gary, moving there from South Carolina. "He was a prominent member of the African American community," Tolbert said. "He would go on to work for the federal government and is credited with overseeing the design and construction of numerous post offices and courthouses throughout the Midwest."

The hospital, opened in 1929, is on the brink of collapse, and it is more than likely to be demolished, if funds become available. It housed its last patients in 1950.

"We have worked with numerous individuals and groups seeking to save the building, but there has always been a lack of attention about the building and its preservation," Tolbert said.

There are many reasons to explain such lack of attention when it comes to black-originated resources in Gary, often with politics and prejudice cemented in their foundations. Such explanations are usually whispered in private—not revealed in public or within books about the city. However, with all the remarkable construction efforts in Gary, each one credited to various ethnic groups, historians find it important that consideration be given to their preservation.

"While some view them as reminders of segregation and the line between races in Gary, they reflect various architectural and building styles that are not being duplicated today," Tolbert said. "More importantly, they show the diversity of culture that truly created and built Gary."

Vee-Jay Records

Vee-Jay Records played all the right notes in the 1950s and '60s, making a name for itself across the country. It was the first major record company owned solely by blacks, predating Motown, releasing hit single after

hit single—from the Spaniels' "Baby It's You" to the Beatles' "Please, Please Me."

Vee-Jay was the first company to sign the Beatles' first U.S. contract to distribute that record in 1963, also focusing on blues, jazz, soul, gospel and rhythm and blues. Other artists included the Four Seasons, Gladys Knight and the Pips and the Staple Singers. The company was founded by husband and wife James Bracken and Vivian Carter, using the initials from their first names to name their love child. She was a successful radio show personality, once hosting a popular late-night program called "Livin' with Vivian." He was a successful businessman who sold their label's first record in 1953.

Together, they sold millions of singles before financial mismanagement ended their meteoric run in 1966. Carter, a Roosevelt High School graduate, died more than twenty years later in a Gary nursing home. The record label's building deteriorated into a dangerous condition, and the lack of concern for its stabilization contributed to its fateful demise. "It is discouraging that a building with such recognized significance—included on Chicago blues tours—was not given more consideration for preservation in its own city," Tolbert said.

The historic building was demolished two years ago without any fanfare.

Steelworker Houses

Known as the "steelworker houses," these rows of homes are located along Fourth Avenue, west of downtown. They represented some of the earliest homes built by U.S. Steel and the Gary Land Company. Yet they, too, have been demolished over the years due to their woeful condition.

Tolbert cites other examples of worker housing throughout Gary, and the region, which are directly tied to the city's industrial heritage.

"With the push for Pullman to become a National Historic Site, the interest in industrial heritage in Chicagoland and Northwest Indiana will grow," Tolbert said. "When interpretation on Pullman and its paternalistic ideology is presented at the historic site, a natural connection to Northwest Indiana will be made. With areas such as Marktown and worker housing in Gary being threaten and removed, the region will not only lose its own history but the potential investment and tourism these sites can generate."

Thomas Edison Concept Homes

The so-called Thomas Edison Concept Homes also were designed as worker housing, with the dwellings' unique angle constructed with concrete, a technique credited to the genius inventor.

"With the growth of Gary and the influx of workers, the earliest housing was designed and constructed based on need," Tolbert said. "So a lot of construction and design techniques were created in the quest to develop the fastest and most economical way to build housing for workers. It really is a testament to American ingenuity."

As most everyone knows, Edison held innumerable patents, but few people know he also had one on cement. In 1906, he invented a mold and construction system for use in building all-concrete houses, according to Indiana Landmarks. In 1913, U.S. Steel executives thought this technique could be a solution to the housing shortage in Gary. The steel giant used Edison's molds to build row houses with detached cottages for the firm's management staff. "I see homes such as these as unique to Gary because

This row of Edison Concept Homes along Adams Street offers a peek at entire streets in abandonment. *Author's collection.*

they show invention by necessity," Tolbert said with a respectful nod to the world's greatest inventor. "Edison's technique was one mold of poured concrete that created a house, including all interior features and details," she said. "The homes in Gary were made from poured concrete, but instead of one mold, they were built by story—pouring one floor mold, letting it set and then doing another floor on top."

Nearly a century after the homes' construction, the nonprofit Partners in Preservation commissioned a multiple-property documentation submission to the National Register. In it, the organization noted that more than seventy of these homes remain of the eighty-six original buildings using Edison's molds. The submission, researched and written by Christopher Baas, offered "historic district" nominations for four clusters: Polk Street Cottages, Jackson Terraces, Monroe Terrace and Van Buren Terrace. Its intent, in part, was to raise awareness of these houses in order to qualify for restoration incentives. No longer the property of U.S. Steel, most of these houses still exist with occupants, but many others are now vacant and in ruins. They will be targeted for demolition.

Downtown Gary

The city's once bustling downtown area is designated as the City Center Historic District and is even listed on the National Register of Historic Places. Since this listing in the 1990s, numerous buildings have been lost and continue to be slated for demolition.

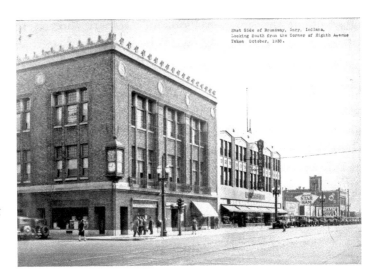

The intersection of Broadway and Eighth Avenue facing south, circa 1930. *Calumet Regional Archives.*

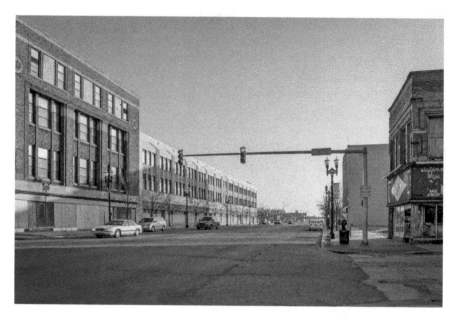

The intersection of Broadway and Eighth Avenue facing south, in 2014. *Cindy Bean photography collection.*

The district is significant for its diverse architecture and building materials but, more importantly, as the city's social, commercial and governmental hub, as with any city. "Arguments are made that all of the old must go in order for revitalization to happen. But other historic downtowns in the region seem to thrive and revitalize by mixing both preservation and new development," Tolbert said, referring to nearby cities such as Valparaiso, Crown Point and Hobart.

Additionally, Gary, Hammond, East Chicago and Whiting are commonly referred to as the region's older cities, which Tolbert finds humorous. "Towns and cities in south Lake County and Porter County are at least fifty years older, and the buildings in their downtowns are actively housing new businesses and uses. So the argument that a building built in 1920 or 1930 is unsuitable for revitalization is moot when buildings built in 1870 or 1880 are prime real estate in other cities."

LANDMARKS LOST TO TIME, NEGLECT AND URBAN DECAY

ABANDONED DREAMS, ABANDONED NEIGHBORHOODS

The soul of the city is gone…gone for good.
—David Gilyan, former Gary resident and a Horace Mann High School graduate

George Bodnar closed his eyes tightly and flashed back more than sixty years in his past. He went back to his childhood home at 817 Connecticut Street on Gary's east side, just a couple blocks off Broadway. His neighborhood was the center of the universe in the 1950s. His home is no longer there—razed long ago—just an empty lot of weeds, ghosts and memories.

"Downtown Gary was the greatest place in the world to grow up," Bodnar said matter-of-factly without a hint of doubt in his voice.

Regardless of section within the city—downtown, Glen Park, Midtown, Horace Mann, Emerson, Miller—former residents shared this same viewpoint about their neighborhood. Most also agree that those neighborhoods are now lost forever. "It was unbelievable living there," said Bodnar, who's now seventy-four and living in nearby Portage. He was one of nine siblings raised in a two-story home in the Emerson school district. It was another melting pot neighborhood in the Steel City, overflowing with different faiths, dialects and nationalities.

The Bodnars, who were Hungarian Slovaks, grew up next to Temple Beth-El and an adjacent Jewish school. They played on the property on

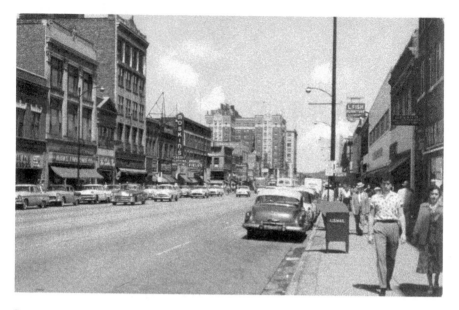

Broadway in the 1950s attracted city residents, out-of-town shoppers and even tourists to the Steel City. *Christopher Meyers collection.*

every day except one. "Saturdays were off limits because they congregated on that day," Bodnar said.

The Bodnars roamed their neighborhood with Greeks, Serbs, Mexicans, Poles, Jews—you name it. They were all raised on hard work, sports and religion. "Everybody knew everybody else, and they all looked out for each other," he said. "No family was any better off than the next one. We didn't know what the word poor meant," Bodnar said.

Bodnar's father, Joe, worked as a steelworker at the National Tube plant. He earned $3,400 in 1948 and raised a family of eleven on it. Rent, coal, electricity, water, food—somehow Joe and his wife, Sophia, pulled it off each year. They were poor but never poverty stricken, the difference between a lightning bug and lightning. Sophia volunteered as a "pink lady" at Mercy Hospital. Joe walked to work or took a bus. He never owned a car; he didn't need one. Gary was designed that way—homes were walking distance to work, school and play. "The only places we went was where we could walk," Bodnar said. "Our downtown neighborhood had everything we needed. We never worried about anything." The kids' playground was the streets, alleys, parks and rooftops. They also could choose from a dozen movie theaters, from Glen Park to Tolleston to Miller. "It was a magical time," Bodnar said.

LANDMARKS LOST TO TIME, NEGLECT AND URBAN DECAY

Bodnar's family had a newspaper stand on Eighth Avenue and Broadway, right in front of the Princess Café, later called the Copper Kettle, next to the Grand Theater. As a boy, he would run home from school and then to the paper stand to replace one of his brothers. When it was his time to be relieved of duty, his brothers would search him from head to toe for swiped pennies or nickels. He learned where to hide them, though, so he could spend his "earnings" at a gas station pop machine on Ninth Avenue and Virginia Street. "There was always something to do," he recalled.

David Gilyan, a former attorney for the city of Gary, echoed Bodnar's fond recollections. Gilyan, a Horace Mann High School graduate, was born in 1940 and spent his childhood in the neighborhood near Eigthth Avenue and Jackson Street. "It was a different era back then," said Gilyan, who now lives in Las Vegas, Nevada, with his wife, Susan, fifty-five, who also was raised in Gary.

"Let's be honest," David said flatly. "The city wasn't always blissful, but it was always beautiful. And it was a beautiful place to be raised." As a young child, Susan moved from the Tolleston section of the city to Glen Park, near Forty-first Avenue and Vermont Street. She remembers spending entire days there with her friends, shopping at Kresge and Ribordy drugstore and having lunch at Beauty Spot Restaurant, one of the city's oldest diners. "They're all gone now," she said with a sigh, noting she left the city in 1977.

David's parents ran a successful paint store at Sixteenth Avenue and Broadway, until it was robbed at gunpoint more than once in the late 1960s. They moved out by 1970, another proud Gary family lost for good to a city in transition. "There was a change in attitude. It was palpable," Gilyan said matter-of-factly.

Tiffany Tolbert, director of Indiana Landmarks' northwest field office in Gary, believes too many neighborhoods have been decimated by random demolitions. These systematic removals of blight leave a significant impact on the overall diversity of housing types in Gary. "I see neighborhoods and areas in Gary—such as Horace Mann, Glen Park and Emerson—being decimated by demolition," she said. "Some of the homes are dilapidated and probably in need of demolition for public safety. But without any standards for new construction or guidelines that capture the character of these neighborhoods and the remaining homes, inevitably, the diversity and individual character of these neighborhoods will be lost."

Former residents like George Bodnar feel too many neighborhoods are already lost, especially his old haunts. The Bodnar kids attended Emerson schools, located a few blocks away from their home. For a couple years there,

all nine siblings took classes inside one of the two adjacent schools. They were proud of their school, proud of its legacy, proud of themselves. Bodnar is still proud, his voice rising while talking about it. "We were winners," Bodnar said proudly. "We won everything."

The progressive school boasted all the newest amenities, including a swimming pool. "It was one of the only schools in the country with an indoor swimming pool," Bodnar said. After the boys did calisthenics or played sports, they were required to take a shower before taking a dip in the pool—naked. Each one was inspected by a coach for cleanliness.

"He checked every boy from head to toe, and everything in between, if you know what I mean," Bodnar joked. "I still can't believe we had naked eighty boys in that swimming pool, but that's how it was done back then."

School officials opened the tennis courts for nighttime dances, and others attended their prom at the Hotel Gary or Marquette Park pavilion in Miller. Some students with tickets were allowed to attend sports sectional games at the Gary Schools Memorial Auditorium. In 1945, Frank Sinatra performed there amid a racially charged incident regarding black kids swimming in the same pool as white kids, among other inequalities. It was a memorable visit for Gary youths of all ages and races. "Our graduating class in 1959 had 176 students, and about 35 were black," Bodnar said. "Some of them are still my friends today."

Emerson grads of all ages stay connected these days through the "Gold to Gray" newsletter, which has subscribers from around the world. Each newsletter is filled with memories and updates about downtown Gary and the Emerson community. "We've stayed together for nearly seventy years," Bodnar said.

A banker for most of his life, Bodnar married in 1964 and moved to Portage in 1971. But his memories of Gary have never migrated far from his heart. "It's like it was yesterday," he said.

Every winter, Bodnar's mother made her seasonal specialty, jelled pig's feet, placing the containers on the family's back porch. Overnight, as the fat rose to the top, black soot from the mill would cover the fat. "We just scraped it off," Bodnar said.

All the neighborhood kids enjoyed playing at Buffington Park, a block away, which had a swimming pool. Or they'd walk to the beach in Miller, a three-mile jaunt down the railroad tracks. They'd stay out all day and into the night. A game of pick-up baseball served as after-dinner entertainment. Crime was what happened in other cities, not in Gary. "Our parents never worried about us," Bodnar said. "It didn't matter what age you were."

A decorative pin from the Gary Golden Jubilee celebration in 1956. *Author's collection.*

In the evenings, they melted into the steady stream of foot traffic, dubbed by retailers as the "Broadway bustle," with most stores staying open late to accommodate shoppers. Most stores were closed on Sundays, a sacred day reserved for God and family, in that order.

"We had it all; we had everything," Bodnar said while looking through old issues of the "Gold to Gray" newsletter. "Look, it's all here. All those memories. We will never forget."

This unforgettable utopia on the southern tip of Lake Michigan ended in the 1960s, Bodnar said with a shrug. He still returns to Gary, mostly to visit his older brother and nephew. It's always bittersweet, though. The same repeated crash of the past and the present. How does he feel while driving through his old neighborhood?

"Don't ask," he replied disgustedly. "It's lost, I tell ya…it's lost forever."

David Gilyan agreed with a sigh: "Gary could have been so different. But now, the soul of the city is gone. Gone for good."

POSTER CHILD FOR URBAN DECAY

We live in a war zone in this city.
—*Thomas Johnson, longtime Gary resident*

Thomas Johnson angrily slapped his bum knee and blurted out his bottled-up frustrations about his beloved hometown. "Our city is going to hell," he said, shaking his head back and forth. His wife of more than a half century,

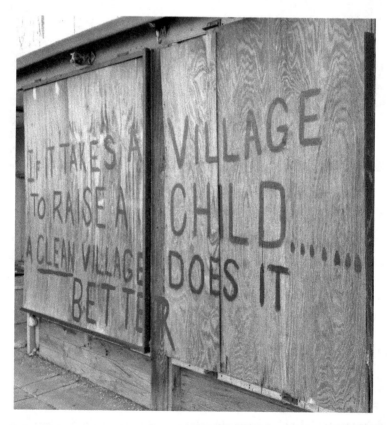

A boarded-up Broadway storefront expresses the frustrations of city residents. *Author's collection.*

Priscilla, corrected him from a different room in the couple's Gary home. "Our city has *gone* to hell," she noted with a smirk.

Johnson, a lifelong Gary resident who's been voting since the Truman administration, was once a political activist. He still is in his golden years, though he's more "political" than "activist" in his older age, he joked. "I speak my mind," he said flatly. "He always has," his wife added. Each time he votes for Gary's mayor, he hopes his troubled city will resurrect from its current ruins. Each time, he's bitterly disappointed. "I've watched this city go to nothing," he said. "It's a shame." His wife echoed: "It's a darn shame."

The Johnsons speak for thousands of longtime Gary residents who've seen their city rise, fall and then fall again and again. They've watched streets crumble, buildings get abandoned, businesses close, neighbors flee, crime and unemployment rise while income and city revenue plummet. They've watched their city get tagged as the country's "murder capital" in the 1990s. They've watched their city lead the state in foreclosed homes that are abandoned. And more than seventy people have been reported missing from the city in the past five years. Urban decay is a term they've heard too many times, typically next to words such as gangs, drugs, guns, homicides and poverty. It has caused many residents to lose faith in a city that's been under attack for decades.

"We live in a war zone in this city," Johnson said disgustedly.

In 2014, the city suffered another ambush on its already war-torn reputation. Not only was it riddled with fifty-three new homicides that year, a serial killer used abandoned homes as burial sites for his many victims. The bodies of six women were found inside empty homes across the city, allegedly dumped there by Darren D. Vann, who was charged for the killing of at least two of them. The high-profile murders focused the national spotlight on Gary's long list of abandoned homes and other buildings. Just what the city didn't need amid efforts to attract new residents and new faith. One in every five homes is vacant, totaling up to ten thousand dwellings that pockmark the city, according to city records.

In the 1990s, a program labeled Operation Crackdown used federal funds and the Indiana National Guard to demolish abandoned homes. Its goal was to raze the homes that were being used for drug users and gangbangers. The program couldn't keep up with the number of vacant homes, each one a lost landmark to a degree.

In 2013, graduate students from the University of Chicago's Harris School of Public Policy began surveying these properties and other sites for what has been labeled the Gary Project. In conjunction with the city, its collective goal

The once bustling Broadway business district is now covered with façades of businesses, littered with graffiti and neglect. *Author's collection.*

was to catalogue every vacant building, an arduous task for an ambitious revitalization project. "This practicum is part of an ongoing and broader collaboration between the Chicago Harris and the City of Gary, Indiana, to assist Gary Mayor Karen Freeman-Wilson and her administration with efforts to revitalize Gary, while offering students real world opportunities to develop and implement solutions for significant urban policy challenges," according to the project's summary. "Students in the practicum will conduct research, analyze data, compile information, and develop and present proposed strategies and policy recommendations to officials from the City of Gary on a specific set of urban policy challenges."

In early 2015, the survey concluded that roughly thirteen thousand of the city's structures—more than one-third—are considered blighted. One in five residential dwellings and one in four commercial buildings are vacant, the eighteen-month survey determined. City officials estimate it would cost more than $30 million to remove those abandoned homes and buildings. Too many of the owners of abandoned properties, however, have fled the city and their responsibilities, according to region historian Ronald Cohen.

"People are responsible for these problems. This is not just a fact of some natural situation. Someone is to blame," Cohen said.

In early 2014, the Obama administration included Gary in its Strong Cities, Strong Communities program, which provides federal funds to revitalize targeted communities of urban blight. Gary could be the poster child for such a program.

"The federal program aims to strengthen neighborhoods, towns, cities and regions around the country by strengthening the capacity of local governments to develop and execute their economic vision and strategies," according to a White House press release. "Strong Cities, Strong Communities bolsters local governments by providing necessary technical assistance and access to federal agency expertise, and creating new public and private sector partnerships."

In May of that year, the city announced news of receiving $6.6 million from the state's Hardest Hit blight elimination program. City officials estimate it would cost upward of $100 million to demolish every vacant home in the sprawling city, from Miller to Tolleston to Glen Park to Midtown. "People need to understand that not every abandoned structure will be knocked down at this time," Gary mayor Karen Freeman-Wilson said in a statement after the announcement.

Since the polarizing administration of former mayor Richard G. Hatcher, hundreds of millions of state and federal dollars have been poured into Gary for various revitalization and redevelopment projects. The majority of those funds served as only expensive Band-Aids on a hemorrhaging city. In 1996, when two windfall-promising casino boats docked at Buffington Harbor in Lake Michigan, they essentially barged in more Band-Aids. City officials had little choice but to gamble on the boats' needed revenue stream; nevertheless, Gary continued to bleed tax dollars, businesses and citizens.

Only the city of Detroit, Michigan, compares to the urban decay suffered by Gary, according to a 2014 study by the Federal Reserve Bank of Chicago. It concluded that Gary has sunk to such a low point that success is now defined by curbing future decline. One-quarter of its residents live below the federal poverty mark, median income rates hover just above 50 percent of the nation's average and nearly half of its population rents housing, a much higher rate than the rest of the country, the study stated.

The local steel industry is still a large employer, but fewer Gary workers toil in the mills. More now work in the lower-paying service sector, not the manufacturing field, as with previous generations of residents. Between 1980 and 1986, the region's manufacturing losses totaled 42 percent, mostly

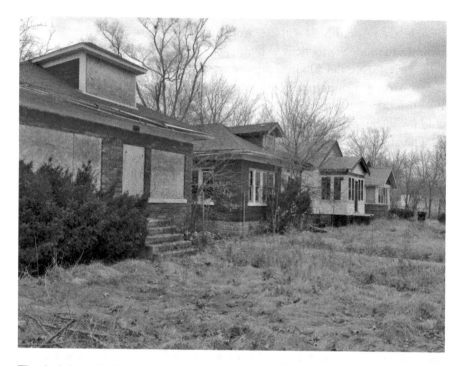

The city is littered with more than nine thousand abandoned homes and buildings, such as this block of homes along Virginia Street. *Author's collection.*

in the steel industry. Because of this shift, in part, the city's workforce is less educated than the national average, and unemployment is much higher than in most cities. "By all accounts, Mayor Freeman-Wilson has the challenge of holding and beginning to reserve 40 years of decline and disappointment in the short time before the next election cycle begins," the study concluded.

Long ago, the *Gary Post-Tribune* newspaper launched a series titled "If I Were Mayor," asking readers for ideas on improving city government. Responses included grievances against a city in the works, back when it was considered an "urban experiment" by national planners. In the twenty-first century, residents are tired of failed experiments. "If I were mayor, I'd focus on crime, public safety and a larger police force," said Johnson, a former mechanic, carpenter and Bud Company retiree. "Too many people here are getting shot and killed. And for what?"

A similarly sad refrain was echoed by the family of Harold L. Jones, who was gunned down during a robbery of his store in the summer of 2006. Like so many—too many—homicide victims in this city of faceless murders, his shooting death was nonchalantly dismissed by Northwest Indiana residents.

Just another killing in Gary is a familiar mantra for outsiders to reinforce their image of the city. This is another byproduct of urban blight, which can disconnect a city from surrounding areas and others' empathy. Jones, who everyone called "Mr. Harold," put a human face on what had too often become a faceless crime.

He co-owned East Point Grocery on Gary's east side. Kids called him "Mr. Harold" from his decades as a bus driver before he called it quits. Long after retirement, Mr. Harold woke up early every weekday to be a school crossing guard before running the store. He didn't have to be. He wanted to be.

"Good morning, Mr. Harold," the familiar-faced kids would say.

"Good morning, yourself," he'd reply.

On a Sunday morning, Mr. Harold stepped into the store before church, dressed to the nines. A customer called to ask if she could send her grandson there to pick up a pair of pantyhose. Of course Mr. Harold said yes. "He'd give you a thousand dollars if he had it," said his sister, "Miss Jessie" Cain.

Despite handwritten signs in the store warning "No CREDIT" and "No PASS OUTS!" Mr. Harold often issued credit to regular customers until the first of the month and wink-and-nod pass outs to needy neighbors. On the store's front counter display case, taped amid several old photos and some dusty memorabilia, was a telling newspaper clipping. Its headline warns store customers, "House bill OKs right to shoot." Jones taped it there to warn potential criminals that the law now allowed him to legally defend his store if needed.

"You couldn't find a better person than Harold," his sister said. "Go ahead, ask around. They'll tell you the same."

On a day when the seventy-nine-year-old U.S. Army veteran should have been at a church service, he met his maker under hellish circumstances. Two assailants entered his store, pulled out weapons and demanded his money. Mr. Harold tried shooting back with his own gun, but he missed, according to his family. "They got the jump on him," his sister sighed.

The killers got all of fifty dollars, the regular kitty for each new day of business. Mr. Harold was shot in the neck. His body was found by a relative behind the counter. That's how Mr. Harold died. Here's how he lived.

Store customers called him "Wild Bill" and "Fuzzy," nicknames that stuck long ago. The lifetime Gary man worked seven days a week and didn't like calling off. The store was his life, not his livelihood.

In his youth, he was the Jessie Owens of Indiana, setting track and field records all the way to North Carolina State University, where he majored in

physical education. He was eventually inducted into the Indiana Association of Track and Field Hall of Fame in 1994. A weathered *Post-Tribune* clipping of this feat is still taped to a wall in the store. As an adult, this father of eight ran for Fifth District Committeeman as a Democrat under the platform "Your friendly bus driver."

Since his death, a busload of fresh-faced ideas, programs and strategies has been hauled into the city to counter its lingering woes. As city officials have learned through the years, urban blight can be contagious. Rebounding from a chronic illness is even more difficult for terminal patients.

Critics of the city—which include mournful natives and disconnected outsiders—wrongly think that Gary should simply disappear from the map and quietly die, as old elephants instinctively do, according to legend. It's a myth, however, in both regards. Depending on which parts of the city you're pointing to, it could be either a vibrant community or a ghost town. Sometimes from block to block. Is Gary half empty or half full? It depends who you talk with and where they live. The Johnsons have been besieged by disappointment and frustration for more than forty years. You'd think after all these decades, the couple would have lost hope for their city and its future. They haven't. "It's our home," Johnson said matter-of-factly. His wife corrected him again: "Our *only* home."

THE CITY'S DEEPEST RESOURCE: YOUTH

Which of you will be history-makers in the world?
—Naomi Millender, Gary Historical and Cultural Society

Gladys Johnson walked slowly through the parking lot of St. John Lutheran Church, appropriately enough the oldest surviving place of worship in the city of Gary. Johnson, the oldest Gary resident born in the city, turned one hundred years old on July 17, 2014. Johnson was one of only three people born in Gary on that summer day in 1914, and the only one with such a claim to still live there. The city celebrated Johnson's birthday by formally introducing her to dozens of city youth at the historic church. "Which of you will be history-makers in the world like Ms. Johnson?" asked Naomi Millender, Johnson's niece. Dozens of young kids raised their hands with a sincere look of determination, a hopeful attitude that only a child could possess. On that day, the children took a break from their Summer Enrichment for Learning

Program, hosted by the Gary Historical and Cultural Society. They took a pause to listen to Johnson, who was older than all of them combined. She came to pass the torch of tradition to younger generations of Gary residents. This is how history gets told to impressionable young minds. This is how the city's deepest resource—its youth—gets a life lesson that doesn't come with a degree or commencement ceremony. "If we get to them early enough, they will be our city's future," said Millender, whose ninety-four-year-old mother, Dolly Millender, founded the historical society in 1976.

Johnson, a long-retired educator, was the first principal of Drew Elementary School and a longtime leader of the Gary Urban League. She fought against racism, prejudice and discrimination while always keeping her eyes on the prize—educating the city's youth. On her 100th birthday, she recalled her days as principal of Garnett Elementary School, when pop star Michael Jackson attended the school. She still lives near his boyhood home. "He used to come to school tired, from staying up so late the nights before, performing," she told the kids. "So we let him sleep." A few kids asked her questions about the King of Pop, who serves more as a mythical figure of hope to them than a dead musician who once performed in their city. The kids joined to sing Johnson "Happy Birthday to You," including a version from two girls just learning how to play it on violin. Music, a universal language in any city, remains the most affordable currency of communication in Gary, from old gospel hymns to recycled remakes of Michael Jackson songs. Jackson was forever lost to the city when he died in 2009, and Johnson died in late 2014. Both, however, were true history-makers who left their mark on the city's youth in different ways, for decades to come.

Former Gary mayor Rudy Clay often preached the value of Gary youth during his "city on the move" lesson plans. Just before taking the podium for his 2007 State of the City address at the Genesis Convention Center, Clay slipped into a back hallway. There, a group of young children eagerly waited to meet him. The children, part of the Banneker Dance Troupe, had just finished performing for Clay and the event's special guests. The kids attended grade schools from Tolleston, Emerson and Marquette. Clay chatted with the children, handing out fliers with his photo on them. One girl stared at the flier and then back up to Clay, taking a few seconds to realize it was the same person. Clay enjoyed chatting with kids, often telling them the same message: "Keep doing your best, and you'll be the best." That same year, Scooter Pégram reminded his Roosevelt High School students of a similar message despite their glaring challenges in the city. He did so by asking them

to examine a poem by deceased rap artist Tupac Shakur. "OK, y'all, what's going on with this poem?" Pégram asked the students.

Shakur's poem asks: "Did you hear about the rose that grew from a crack in the concrete? Proving nature's law is wrong it learned to walk without having feet. Funny it seems, but by keeping its dreams, it learned to breathe fresh air. Long live the rose that grew from concrete when no one else ever cared."

One of the students, seventeen-year-old Marquise Hicks, immediately replied to the challenge. "I think Tupac was saying that he was the rose and that the concrete was the struggle," he told Pégram. Another student, Alexis Rivera, piped in, "Concrete is universal. We all have struggles." Another student added, "It reminds me of myself." Another one noted, "There are a lot of roses in Gary's concrete." Pégram, a professor of minority studies at Indiana University Northwest in Gary, nodded and smiled. He knew that the students nailed the poem's meaning.

The last of nine sessions, titled "Conversations with Gary Youth," took place at the high school, which is now called the Roosevelt College and Career Academy. The program promoted reading, discussion and interaction, encouraging students to examine themselves and their relationships with others under the context of issues such as identity, community, justice and equality. Pégram organized Conversations with Gary Youth and applied for a grant to fund the project through the Project on Civic Reflection at Valparaiso University. During each session, students read assigned texts—from Martin Luther King Jr., Bob Marley, Nelson Mandela, Soujourner Truth and others—and then engage in reflective discussions on how it relates to their own lives. On that day, the students read poetry by Shakur—the writer, not the rapper—whose activist mother was coincidentally a Black Panther, which was Roosevelt High School's mascot.

After each reading, conducted by the students out loud, they were asked the same question by Pégram, who echoed musician Marvin Gaye from decades ago: "What's going on?"

Odis Richardson, a longtime teacher there and co-organizer of the program, wouldn't let the students remain silent. "Come on now, just jump in," Richardson told them. The teenagers didn't let him down. They spoke from their hearts and from their heads. Just like Shakur, they spoke about their reality of growing up in a concrete clutter of prostitutes, drug users, gangbangers, poverty, shootings and more liquor stores than churches. Their frank conversation was descriptive of the problems and prescriptive of the solutions. It wasn't a debate but a discussion, not a monologue but a dialogue. "There is no easy way out in Gary," Hicks said, shaking his head.

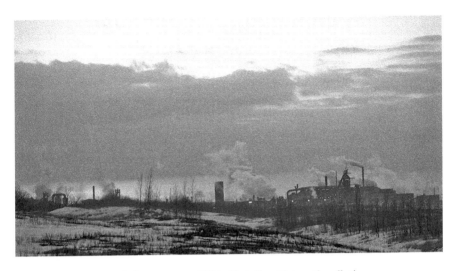

U.S. Steel smokestack skyline at sunset, 2014. *Cindy Bean photography collection.*

One girl admitted, "I don't have a happy household." Another teen said, "Those crackheads, prostitutes and homeless have the same skin color as me. It hurts." Another student countered, "It doesn't matter. We need to let ourselves shine." They shined all afternoon.

At the end of the program, Pégram and Richardson gave the students plaques and certificates, as well as a book for summer reading and, more importantly, for reflection. Pégram said those students are a perfect example of who is usually overlooked in Gary amid the endless headlines of crime, murder and corruption. With all of Gary's failed projects and wayward plans—beautification projects, redevelopment plans, economic redevelopment—this was one project that invested directly into the city's most promising and abundant natural resource: its youth. Each of them is a blossoming rose looking for their crack in the concrete.

This is still the largely untapped demographic of Gary citizenry that can "fill negative spaces" in a city pockmarked with negative spaces. This term is the most intriguing initiative of "Imagine Gary," a creative arts community service project that kicked off in 2014 at the juncture of volunteer mentors and city youth. Actually, it took place at the intersection of Fifteenth Avenue and Massachusetts Street, where dozens of talented Gary youth joined a handpicked team of working professionals. It didn't matter that some of the participating youth were painting an outdoor mural for the first time. What mattered was that they filled negative space there, as well as, hopefully, in their minds. "We're here to not only beautify our community but also to

empower and inspire our youth," said Alicia Nunn, executive director of the public service group ARISE (Accountability—Respect—Innovation—Success—Entrepreneurship). "We want to expose kids to the history of this property but also to the hope for their future."

Through creative "place making," they painted murals at the Stewart House Urban Farm and Garden with help from Creative Initiatives for the Public Space, LiveArts Studio, Christ United Methodist Church and a professional artist, Ish Muhhamad. He led the group in a studio workshop, later teaching them how to paint the mural. This group of young Gary artists-in-the-works included Jerry Crisler, Justin Brooks and Martrell Por. The property at that otherwise unremarkable corner is owned by Christ United Methodist Church, where members plant and harvest sustainable food for the community. The site is the former home of the Stewart Settlement House, which for nearly fifty years sheltered and aided blacks who migrated from the south to Gary for steel mill jobs. "The church started this garden, and we wanted to spruce it up with this art project," Nunn said as kids took turns painting a large metal storage container.

"Before this mural was painted, this container was just covered with rust," said Dionte Glover, an ARISE board member and youth coordinator. Glover also is co-owner of 444 Grill in the Miller section of the city, which houses weekly performance arts shows by the youth. His job, in part, is to polish their natural talents through various arts, such as poetry, rap music and even playing spoons. "I just stand back, coach them and watch them take off," he said. "I almost came to tears when I watched them put all their skills and talents together for their last show."

The overall project was inspired by a Montreal-based, multi-artist collaboration that drew from youth curriculum, titled En Masse Pour Les Masses. Through similar initiatives, that group has hosted mural projects at the School of the Art Institute of Chicago and the University of Chicago. The concept is for participants to be given the opportunity to work collaboratively on large-scale, black-and-white productions, guided by artists who take on a mentorship role, Nunn said. Their hands-on approach allows artists to empower, inspire and pass on knowledge to all those involved. In turn, participants develop a sense of ownership, pride and ambition for their own personal practice, she added. The new Imagine Gary project swirls together resources from several groups on the same public palette. This includes Creative Initiatives for the Public Space, an organization dedicated to arts-based solutions for community prosperity and social good, and LiveArts Studio in Gary. "This style is similar to the way I teach my art classes," said

Dionte Glover, youth committee chairperson for ARISE (Accountability—Respect—Innovation—Success—Entrepreneurship), leads a group discussion with Gary youth. *Whitney Springfield.*

owner Desire'e Simpson. She helped the youth create symbols, images and words to illustrate what the urban garden at that site represents, in both its past and future. This was first done on a drawing board where students learned how to fill negative spaces, both artistically and then philosophically. "We have a beautiful assembly here of what everyone contributed," she said while overseeing the mural project.

Nunn best summed up the program and, to a larger degree, the critical importance of city youth to overcome so much that's been lost through the decades. "This is the new legacy we're trying to create here, revitalizing Gary one negative space at a time."

"Another Giant Step for Gary"

As this book illustrates, so much has been lost in a city that once promised so much more. On the other hand, Gary still has marketable resources at its disposal, most notably its geographical location. Its proximity to Chicago

remains an ace in the hole, just as it was more than a century ago when U.S. Steel first eyed its Lake Michigan shores. Other assets include ongoing lakefront development, urban farming, existing rail lines, the return of the popular Gary Air Show and the expanding Gary/Chicago International Airport. The seven-hundred-acre facility and adjacent property is considered the third airport of the Chicago metropolitan area, serving several commercial airlines before each one eventually took off and never returned. The airport's success is a major factor in the city's future, as is the downtown area, which for too long has been an anchor to a sunken ship. Optimism is resurfacing inside the historic Gary State Bank building on the southwest corner of Fifth Avenue and Broadway. Built in 1929 to replace the original 1906 building, city officials hope the bank can buoy redevelopment along Broadway. In late 2014, city officials and community leaders gathered there to celebrate plans as the new home for Centier Bank.

"This is another giant step for Gary as we work to revitalize the downtown area," said Mayor Karen Freeman-Wilson. "A team of devoted people put their passion and vision together to develop a plan designed to spark even more growth on this corridor."

The 504 Redevelopment Groups and the city's Economic Development Corporation are the co-developers responsible for Phase I of the redevelopment. The development team received $2.87 million in tax increment financing and control of three adjacent properties along Broadway. "The preservation of this building and the razing of the Sheraton Hotel represent the start of the resurgence of downtown Gary," Freeman-Wilson said.

Mike Schrage, president and CEO of Centier Bank, said at the ceremony: "Success for Gary means success for Northwest Indiana. We expect to see other businesses come, invest and build on what we have started."

According to a study released in 2014 by the Federal Reserve Bank of Chicago, Gary has already hit rock bottom. No other city, except for possibly Detroit, Michigan, epitomizes American urban decay to a similar degree, the study states. "There is almost no way not to make it better," one interviewee stated in the study.

The study profiled ten midwestern cities, each one struggling through "significant manufacturing job loss" in recent decades. "We did this to help the residents of these midwestern cities better understand the approaches that contributed to their rebound," said Susan Longworth, a member of the bank's Division of Community Development and Policy Studies.

"Under the leadership of Mayor Karen Freeman-Wilson, Gary is taking concrete steps to send a message that it is no longer 'business as usual' in Gary,"

Gary mayor Karen Freeman-Wilson, elected into office in 2012, believes the city's biggest challenge is lost pride. *City of Gary.*

the study stated. The city is divided into ten economic development zones to allow for retail corridors; transit-oriented development; entertainment, university, educational and technical districts; the airport; and three light industrial parks.

"However, according to city leadership, the primary challenges to executing these plans include a lack of available buildings that have been adequately maintained, or contiguous open land for building, and a local mindset that would rather preserve the status quo than wrestle with outside interests," the study stated. Freeman-Wilson stated in the study that her number-one priority is to increase the assessed property valuations in the city. The state's caps on property tax revenue have had a "dramatic" impact on Gary in particular.

Regarding the city's manufacturing woes, forty years ago, roughly half of Gary's jobs were in that industry sector. "These jobs did not require

postsecondary education or even high school graduation. At that time 57 percent of Gary residents did not have a high school diploma. Only 13 percent had pursued any college at all," the study stated. In 2010, the city suffered an unemployment rate of more than 17 percent, compared to 8 percent and 7 percent at the state and national levels, respectively.

Making matters worse, more than one-fourth of Gary families lived below the poverty line, compared to less than 10 percent at the state and national levels. Also, the city's population is highly rent dependent, with a renter occupancy rate of 47 percent, over 10 percentage points higher than the national rate, the study stated.

More importantly, the city's "negative perception issues" are keeping its redevelopment efforts grounded, from a public relations and marketing perspective. The potential for change exists in Gary but only if it's allowed to happen.

The report offered recommendations, leading with the fact that Gary alone cannot support the struggling Gary/Chicago International Airport. The study stated:

> As such, the airport should better position itself by modifying the structure of the existing airport board to better represent the broader regional constituency that the airport is positioned to serve. This repositioning would serve to broaden support from both the business and political communities and provide a more logical rationale for financial support.
>
> Some resources have the potential to help: Strong regional partners ready with investment, a new spirit of accountability at city hall with a team ready to execute, resources and programs ready to train a young workforce, and a large industrial presence that continues to make significant investments in the area.

The study concluded: "In a city where leaders define 'success' as a halting of decline, hopes are riding high on Mayor Freeman-Wilson. She and her staff have the challenge of halting and beginning to reverse 40 years of decline and disappointment in the short time before the next election cycle begins."

In January 2015, Freeman-Wilson filed for reelection for her second term in office. "We are headed in the right direction, and I would like the opportunity to continue on this path that is leading to Gary's revitalization," she said. In her State of the City address at the Genesis Convention Center, Freeman-Wilson touched on several challenges facing her administration, such as financial troubles, the lack of salary hikes, urban blight and outdated equipment. She

also noted her staff's accomplishments since being in office, including the whittling of the city's debt by $17 million (out of $43 million), a decrease in crime in 2014 and the acquisition of new police cars and ambulances.

"I am here to give a message of progress on our city," Freeman-Wilson told the audience. "Some get discouraged when they hear about the planning stages and think there will be no action, but when you see streets being paved, buildings being knocked down and others going up, that's proof that our plans are being put into play."

LOST PRIDE: A MAYOR'S MEMORIES

We understand the challenges, but we're committed to turning this around.
—Gary mayor Karen Freeman-Wilson

Gary mayor Karen Freeman-Wilson didn't hesitate for a second when recalling what she misses most from her beloved city's past. "I miss the commerce," she replied fondly. "I miss all the stores. I miss the hustle and bustle. And the opportunities to get what we needed without leaving the city."

Sears, Gordon's, Goldblatt's, Tri-City Shopping Plaza and Village Shopping Center. Kroger, A&P and Tittles. Gary featured countless retail opportunities in the 1960s and '70s, back when Freeman-Wilson grew up in the city's Tolleston neighborhood.

"On Thursdays, I remember getting Goldblatt's sales papers so I could buy a 45 [rpm] record for sixty-nine cents," she recalled. "Or a record album for $4.99."

She and her mother would drive downtown and then walk up and down Broadway eating chocolate graham crackers while window-shopping. They seldom had to venture out of the city for their shopping needs. When they did, it was usually to River Oaks Mall in Lansing, a special treat two or three times a year.

"We didn't need to leave the city; we had what we needed here," said Freeman-Wilson, who lived in a home near Nineteenth Avenue and Arthur Street well into her adulthood.

She was raised in a working-class, all-black neighborhood peppered with working professionals, teachers and millworkers. For entertainment, she and her friends watched shows and movies at the Glen Theater, the State Theater and the Palace Theater. They also attended plays, pageants and

Gary mayor Karen Freeman-Wilson stands on the demolition site of the former Holiday Inn/Sheraton Hotel in 2014. *City of Gary.*

musicals at Seaman's Hall, adjacent to City Methodist Church, which served as the cultural center of the city—until it didn't.

"The stage is still there but not much else," Freeman-Wilson said wistfully.

Flashing back to her teen years, she giggled like a schoolgirl when recalling where she first learned to curse. It was at her mother's workplace of more

than twenty-five years, the Neighborhood House, which later became Gary Neighborhood Services. "It was a settlement house, and I was playing outside with my friends," she said. "My mom heard me curse, and I just froze. I knew I was in trouble. I was too old to get a whoopin', but it wasn't pretty."

As a young lady growing up, she lived a somewhat privileged upbringing. "I was a spoiled brat," she confessed. She didn't work the typical jobs that most teens did, but one year, she toiled in the city's summer program under former mayor Richard Hatcher. Otherwise, she trekked out of the city to attend academic camps or travel tours during her summer breaks.

"My mom was big on those," she said.

The 1978 Roosevelt High School graduate and valedictorian lived in between that prestigious school and the newer West Side High School. She chose Roosevelt because her mother worked just two blocks away. "There was a huge rivalry between both schools," she noted.

Teachers played an extremely influential role in her early life, guiding her to the success she would later find at Harvard University, Harvard Law School and similarly influential public office positions.

As a high school junior, Freeman-Wilson played in the band and on the basketball team. But something had to give if she wanted to be the top student in her class. The principal called her into his office with a firm suggestion: forget about scoring points on the basketball court and instead score more on her grade-point average. "I was off the team the next day," she recalled. "I became the statistician."

The numbers always added up for her eventual return to Gary. "I always wanted to come back home to live and work," she said. Most of her college and law school essays reflected this master plan in the works. Throughout law school, she bounced around her idea of running for mayor in the court of public opinion. It certainly wasn't a slam-dunk, by any means.

After being recognized as an honors graduate at Harvard Law School, her first "real job" came as the Lake County deputy prosecutor. She also served as the twice-elected Gary city judge and as Indiana attorney general.

After losing two previous mayoral elections, Freeman-Wilson won in 2011 with a landslide 87 percent of the vote. She became the first woman to lead the City of the Century and the first African American female mayor in the state. "There's no place like home," said Freeman-Wilson, echoing Dorothy from "Oz."

Still, her hometown is riddled with problems, challenges and flat-out failures: a slashed city budget, a broken educational system, a crumbling infrastructure, chronic poverty, a hemorrhaging population, a tax base on

life support and violent crime issues, highlighted by fifty-three homicides in 2014. "We have our obstacles to overcome," she said optimistically.

Freeman-Wilson lives with her husband, Carmen Wilson, and her mother, a stroke survivor. Her mother, whose parents came to Gary from Mississippi, also was born and raised in the city. She, too, remembers a once vibrant and energized municipality, unlike Freeman-Wilson's daughter, who attends Howard University. "This is all she knows," Freeman-Wilson said, referring to the city's current state. "Even the younger members of my administration don't really remember what Gary used to be. The city started to deteriorate in the mid-'70s."

One focal point of this deterioration was the Sheraton Hotel, which lurked in the shadows of city hall for decades, as well as through much of her mayoral regime. The dilapidated high-rise felt like an albatross around her neck until its demolition in late 2014. It also served as a symbolic microcosm for the city, another empty structure with no residents, no purpose and no future. "It was the last thing I wanted out-of-towners to see when they visited here," she said. "Not to mention potential new businesses visiting our city."

Freeman-Wilson recalls cringing when told that a high-profile funeral procession traveled through one of the worst parts of the city. "It's one thing to hang your dirty laundry in public but quite another to invite guests to drive past it," she said. Critics of the city already claim that a funeral for Gary is long overdue. Freeman-Wilson disagrees. "Clearly, this city was once a mecca in this region and state," she said matter-of-factly. "This is what drives me today. We can still be a mecca but in a different way. Gary can still be something of significance to this region and state. I'm sure of it."

With that said, her heart breaks when she sees hopelessness in residents, particularly youths who never knew the city's heyday. For them, and for too many others, something intangible but profoundly crucial is missing in their lives. She summed it up in just two words: lost pride.

AN AUTHOR'S EPIPHANY

In 1962, I was born in Gary, back when the city was still enjoying its heyday, just six years after its much-heralded Golden Jubilee celebration. I knew nothing about Gary's fabled history or its looming downfall. In my world, inside the Glen Ryan Subdivision on the outskirts of Miller, I lived quite the *Wonder Years* upbringing. Yes, I ventured downtown for shopping, events and parades in my youth, but my daily orbit circled around only my neighborhood. As I grew up, my hometown grew into its current state. I was too young, and too self-absorbed, to take notice. I didn't realize I was living in the shadows of history.

As I entered adulthood, my city seemed to remain the same for decades to come: stagnant and atrophied, as this book has explained, possibly too harshly. While doing research for this book, I learned so much about Gary that I had formerly not known. Not only its beginnings but also its best days, many which came before I was born.

While driving through the city to take notes for this book, Gary came alive amid all the ruins and desolation. Its streets once again bustled. Its neighborhoods again thrived. Its stores again filled with shoppers. Its churches brimmed with believers. I could actually imagine it as it used to be. And still I couldn't imagine what it must have felt like for those many generations of Gary residents who came before me. No wonder so many of them are heartbroken with the city's current state. Admittedly, at times it's like driving through a war-torn combat zone. Through the years, I've become desensitized to the blight, the abandoned buildings, the littered

EPILOGUE

streets, the empty stores and the potential danger. It's like gradually getting used to your own wrinkles, weight gain and forgetfulness.

Returning to Gary this past year with a fresh outlook and renewed perspective, I discovered a new understanding of and a new appreciation for the city. Yes, it's in shambles in many ways. Yes, its challenges outweigh its resources. Yes, it can be sad to return there again and again.

Still, I implore readers of this book to return there with a similar fresh outlook and renewed perspective. Look past the obvious. Look beyond the easy jokes and harsh commentary. Look for more than the city's reputation and convenient stereotypes. Instead, look to the past. Remember what Gary once was to tens of thousands of people. Remember its rich history. Remember its hustle and bustle.

This is the city I discovered while creating this book. This is the "Lost Gary" I never knew existed. This is the epiphany I experienced, and I hope you do, too.

BIBLIOGRAPHY

City of Gary. "City of Gary, Indiana Comprehensive Plan: State of the City Report." 2008. http://www.csu.edu/cerc/researchreports/documents/GaryIndianaComprehensivePlanDraft2008.pdf.

City of Gary, Indiana. "State & County QuickFacts." U.S. Census Bureau. http://quickfacts.census.gov/qfd/states/18000.html.

Cohen, Ronald D., and James B. Lane. *Gary: A Pictorial History*. Virginia Beach, VA: Donning Company, 1983.

Indiana Landmarks. http://www.indianalandmarks.org.

Lane, James B. *City of the Century: A History of Gary, Indiana*. Bloomington: Indiana University Press, 1978.

———. *Steel Shavings*. Vol. 37, *Gary's First Hundred Years: A Centennial History of Gary, Indiana, 1906–2006*. Gary: Indiana University Northwest, 2006.

McShane, Stephen G. Calumet Regional Archives, Indiana University Northwest, Gary.

Meyers, Christopher A. "Gary: 'America's Magic Industrial City.'" http://www.chameyer.net/index2.html.

Millender, Dolly. *Images of America: Gary's Central Business Community*. Charleston, SC: Arcadia Publishing, 2003.

Post-Tribune Newspaper. Selected stories and columns.

Spicer, Steve. "Miller History." http://spicerweb.org/Miller/MillerHistory/ml_hist.aspx.

Svengalis, Kendall F. *Gary, Indiana: A Centennial Celebration*. Guilford, CT: Duneland Press, 2006

BIBLIOGRAPHY

Times Newspaper, Munster, Indiana. Selected stories.

Trafny, John C. *Images of America: Gary's West Side.* Charleston, SC: Arcadia Publishing, 2002.

INDEX

INDEX

INDEX

ABOUT THE AUTHOR

Jerry Davich was born and raised in Gary, Indiana, where he attended William A. Wirt High School, named in honor of the renowned educator who created the "work, study, play" model in the city.

Despite focusing too much on the "play" aspect of this revolutionary model, Jerry began his journalism career in 1995 as a freelance writer, political cartoonist and newspaper columnist. He has since shined a light on society's darkest corners and offered a voice to the voiceless while writing about myriad issues, events and people in the Gary metropolitan region.

Author Jerry Davich stands in front of Union Station near the entrance to U.S. Steel. *Author's collection.*

Jerry has won more than forty state or national awards from various journalism organizations for his work, including innumerable columns on the Steel City. He also is author of the book *Connections: Everyone Happens for a Reason.*

Jerry lives just five minutes from Gary, in nearby Portage, and he never leaves home without his pen, notebook and memories of his storied hometown.